CHRISTOPHER WILMARTH

Drawing into Sculpture

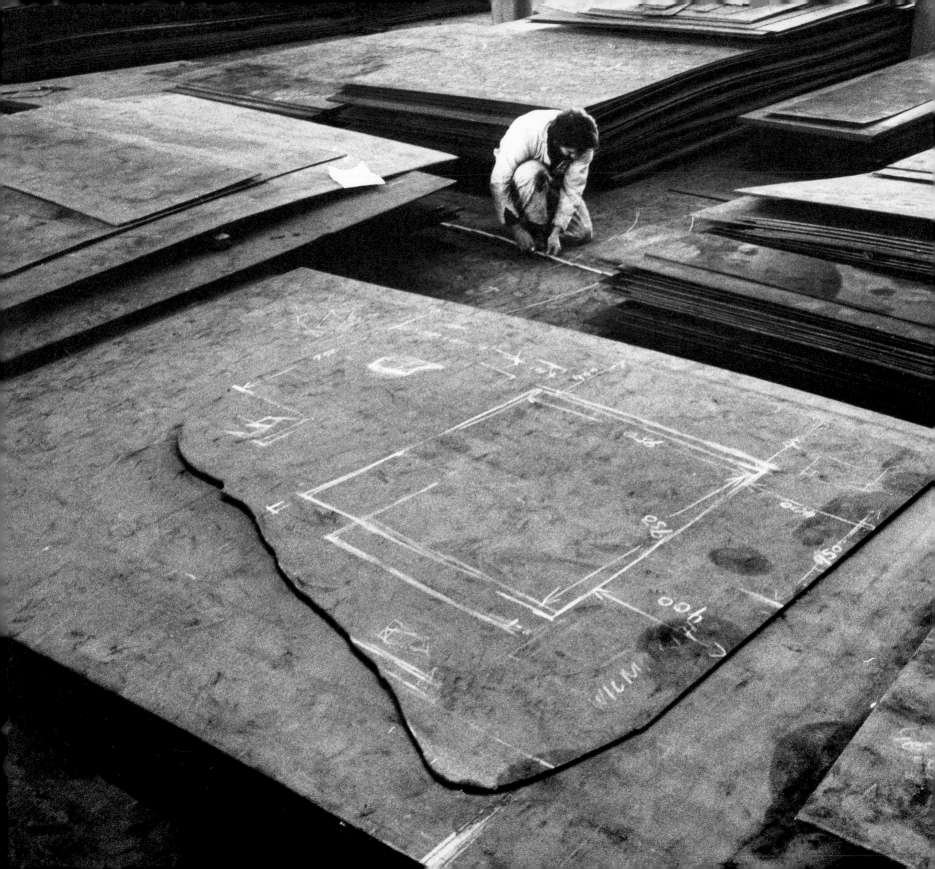

CHRISTOPHER WILMARTH

Drawing into Sculpture

Edward Saywell

HARVARD UNIVERSITY ART MUSEUMS

Cambridge

YALE UNIVERSITY PRESS

New Haven and London

Christopher Wilmarth: Drawing into Sculpture is the catalogue of an exhibition organized by the Fogg Art Museum, Harvard University Art Museums, Cambridge, Massachusetts, on view April 5 to June 29, 2003.

Support for the exhibition and catalogue has been provided by The Fifth Floor Foundation, Agnes Gund and Daniel Shapiro, Martin and Deborah Hale, Sol and Carol LeWitt, and Keith and Katherine Sachs.

PRODUCED BY THE PUBLICATIONS DEPARTMENT
HARVARD UNIVERSITY ART MUSEUMS

Evelyn Rosenthal, Head of Publications
Edited by Evelyn Rosenthal
Designed by Becky Hunt
Separations by Professional Graphics, Inc., Rockford, Illinois
Printed by Snoeck-Ducaju & Zoon, Ghent
Distributed by Yale University Press, New Haven and London

LIBRARY OF CONGRESS CATALOGING-IN-PUBLICATION DATA

Saywell, Edward.
 Christopher Wilmarth : drawing into sculpture / Edward Saywell.
 p. cm.
"Catalogue of an exhibition organized by the Fogg Art Museum, Harvard University Art Museums, Cambridge, Massachusetts, on view April 5 to June 29, 2003"—T.p. verso.
Includes bibliographical references.
 ISBN 0-300-09897-9 (pbk. : alk. paper) — ISBN 1-891771-27-2 (pbk. : alk. paper)
 1. Wilmarth, Christopher—Exhibitions. 2. Wilmarth, Christopher—Notebooks, sketchbooks, etc.—Exhibitions. 3. Artists' preparatory studies—United States—Exhibitions. I. Title: Drawing into sculpture. II. Fogg Art Museum. III. Title.

NC139.W485A42003
741.973—DC21 2003000728

FRONTISPIECE: Wilmarth measuring out the steel plate for *Acore End* in Milan, 1973. Fogg Art Museum, The Christopher Wilmarth Archive, gift of Susan Wilmarth-Rabineau, CW2001.911. Photo by Enzo Nocera.

Contents

Director's Foreword

THE FOGG ART MUSEUM has long had a specialty in sculptors' drawings. More than thirty years ago we mounted an exhibition on the topic.[1] That exhibition, like our present one, concerned itself with contemporary artists, but the solander boxes of our Drawings Department contain sculptor's drawings from as early as the fifteenth century. Just as Christopher Wilmarth's drawings express the light and space (as well as form) implicit in his sculptures, so too a Fogg drawing from about 1480, traditionally attributed to Tullio Lombardo, evokes the luster and expanse of a cognate marble frieze.[2]

In this catalogue, Edward Saywell makes an intelligent and impassioned argument that three-dimensional works in sculptural media—in the case of Wilmarth, glass and steel—can be defined as drawings. We have made that argument before, too, in the Museums' catalogue of Bernini bozzetti; its title begins, provocatively: *Sketches in Clay.*[3] Because of the materials, techniques, and state of preservation of the Bernini "sketches," and because more than three centuries separates us from their making, our interpretation of the terracotta figurines' role in the larger enterprise that was Bernini's workshop depended greatly on technical analysis. Yet had the preparations and postludes for finished sculpture survived—artist's diaries, sketchbooks, and drawings undertaken as first thoughts, extended studies, diagrams and models for fabricators, and record drawings (had they ever existed!)—our Bernini project might have been simpler and perhaps even more conclusive.

Edward Saywell enjoys this advantage. Thanks to the generosity of Susan Wilmarth-Rabineau, the artist's widow, the Fogg Art Museum has acquired the Christopher Wilmarth Archive, which comprises exactly the kind of material that posterity lacks from Bernini. We must also thank here Nina Nielsen and John Baker, Betty Cuningham, and the late Margaret Fisher, who in various ways facilitated our acquisition of the archive. Their collective generosity ensures that it will be preserved and made accessible to all interested parties, from the specialist scholar to the budding sculptor.

We can find in the Fogg's collections a precedent for the window into the creative processes of a sculptor that, in the particular case of Christopher Wilmarth, Edward has here opened wide for us. From 1956 through 1963, a patron, Lois Orswell, and a sculptor, David Smith, collaborated in assembling drawings, paintings, and sculptures that would fairly represent that artist's creative process, with the conscious intention that these would be donated to the Fogg Art Museum for exhibition and study.[4] The understandable reluctance of the artist to yield during his lifetime more of his life's

work and also the limited means of his patron resulted in a choice but limited resource at the Fogg for research on David Smith; it cannot compare to that now available for Christopher Wilmarth.

Edward Saywell has earned his priority in the study of the Christopher Wilmarth Archive. Several years ago he came to the Harvard University Art Museums as an intern, specializing in Italian Renaissance art. Daily pleasures examining our drawings in the original led him to produce an exhibition and catalogue, *Behind the Line: The Materials and Techniques of Old Master Drawings,* with an exceptionally useful glossary, "Guide to Drawing Terms and Techniques."[5] At the same time, at galleries in Boston and New York, Edward was broadening his affections. Combining his growing understanding of contemporary art with his established focus on drawing and attentiveness to niceties of definition, he has arrived at new and original definitions, here applied to Wilmarth.

All the virtues of an academic museum in general and of the Fogg Art Museum in particular have been brought to bear: a tradition of research into the materials and methods of the artist; a preeminent collection of drawings made available for study in every aspect; a specialty in the drawings of sculptors; and above all, an open invitation to the young scholar, to approach new works with new eyes. Edward's perceptions and interpretations will enable the visitors to our gallery and the readers of this catalogue truly to appreciate, in Wilmarth's words, "physical representations of states of mind, reverie, interiors, spirits," and

the processes, aesthetic and artisanal, by which one sculptor brought them into substantial being.

MARJORIE B. COHN
Acting Director
Carl A. Weyerhaeuser Curator of Prints

NOTES

1. Jeanne L. Wasserman, *Six Sculptors and Their Drawings,* exh. cat., Fogg Art Museum (Cambridge, Mass., 1971).

2. *Study for a Frieze with Siren and Acanthus,* c. 1480. Brown ink on off-white antique laid paper, scored for transfer. Bequest of Frances L. Hofer, 1979.63.

3. Ivan Gaskell and Henry Lie, eds., *Sketches in Clay for Projects by Gian Lorenzo Bernini. Harvard University Art Museums Bulletin* 6, no. 3 (Cambridge, Mass., 1999).

4. See the Orswell-Smith correspondence, edited by Sarah Kianovsky, in Marjorie B. Cohn, *Lois Orswell, David Smith, and Modern Art* (Cambridge, Mass., 2002), especially letters on pages 258–59 and 267, and Orswell's statement about Smith, especially pages 297 and 299.

5. The essay and glossary were published as one half of *Harvard University Art Museums Bulletin* 6, no. 2 (Cambridge, Mass., 1998): 7–39. The Tullio Lombardo drawing mentioned above is reproduced as fig. 12.

ACKNOWLEDGMENTS

FIRST AND FOREMOST, I must thank Susan Wilmarth-Rabineau. From the time that I approached her, some three years ago, with the idea for an exhibition on Christopher Wilmarth's concept of drawing, her enthusiasm and generosity have been unflagging. Susan's tireless support culminated in her gift to the Fogg Art Museum at the end of 2001 of the Christopher Wilmarth Archive. It is fitting that *Christopher Wilmarth: Drawing into Sculpture* will be the first occasion on which many of the archival materials, which include over forty sketchbooks, sixty-two maquettes, and hundreds of original technical and childhood drawings, will be exhibited and published. I must also extend very special thanks to Nina Nielsen, John Baker, and Betty Cuningham. Five years ago, in April 1998, I saw Wilmarth's work for the first time at the Nielsen Gallery, Boston, in the exhibition *Christopher Wilmarth: Layers, Clearings, Breath*. The remarkable beauty and sensitivity of the works captured my own imagination, and it was after many stimulating conversations with Nina and John that the idea for this exhibition was born. Their energy and enthusiasm have been inspirational. The encouragement, humor, and wise counsel of Betty, who for so many years was both Chris's dealer and close friend, have also been a constant delight.

I am profoundly grateful to those collectors who generously consented to lend their works to the exhibition: Agnes Gund, George G. Hadley and Richard L. Solomon, Martin and Deborah Hale, Sarah-Ann and Werner H. Kramarsky, Forrest Myers, Nina Nielsen and John Baker, Joanne Soja, Susan Wilmarth-Rabineau, The Estabrook Foundation, the Museum of Modern Art, New York, and a lender who wishes to remain anonymous. Without the financial support of The Fifth Floor Foundation, Agnes Gund and Daniel Shapiro, Martin and Deborah Hale, Sol and Carol LeWitt, and Keith and Katherine Sachs, the exhibition and catalogue could never have happened; with sincere gratitude, I thank them all.

I wish to express particular appreciation to William W. Robinson, Maida and George Abrams Curator of Drawings. His encouragement and enthusiasm throughout the project have been unstinting and enormously appreciated. My thanks go also to Jim Cuno, for his unqualified support while Elizabeth and John Moors Cabot Director, and to Marjorie Cohn, who took up the reins as Acting Director at the start of 2003. I am indebted to all my colleagues in the Agnes Mongan Center for the Study of Prints, Drawings, and Photographs, who make it such an inspiring and special place to work. Particular thanks, though, must go to Miriam Stewart and Michael Dumas for their advice, assistance, and all important humor. For their invaluable help in cataloguing the Wilmarth Archive, I must also thank my student assistants, Anna Lakovitch and Kate Nesin.

10 In making this exhibition and publication a reality, many here at the Harvard University Art Museums have assisted with great patience, kindness, and skill: in our paper lab, Craigen Bowen, and above all, Caroline Clawson, who carried out with care the conservation and preparation of the works; our registrars, especially Amanda Ricker-Prugh, who meticulously oversaw the many loans to the exhibition; Allan MacIntyre and Jay Beebe of Digital Imaging and Visual Resources, who photographed with beauty and skill so many of the works reproduced here; and from the same department, Peter Siegel, Claire Lesemann, and Julie Swiderski; Stephanie Schilling from our Financial Office; Evelyn Rosenthal, for her meticulous editing, and Becky Hunt for designing a beautiful catalogue; and Danielle Hanrahan and her colleagues Kristina Colucci, Peter Schilling, Doug Woodworth, Andrew Tosiello, Dan Gluibizzi, and Gina Cestaro for their care, dedication, and expertise with the installation.

My thanks also go to Joy Sobeck, who edited the wall texts; Tom Delano, who carefully helped with the installation; Michelle Komie and Patricia Fidler of Yale University Press; Frederick Morgan; Arabella Makari; Amy Eshoo; Laura Satersmoen; Kevin Dacey; Patricia Berube; Betsy Miller and all the staff of Robert Miller Gallery; and at the Museum of Modern Art, New York, Glenn Lowry, Director; Gary Garrels, Chief Curator, Department of Drawings; Francesca Pietropaola, Curatorial Assistant, Department of Drawings; and Mikki Carpenter, Director of the Department of Imaging Services.

To Dennis Coy, my heartfelt thanks for opening my mind to so much during the months that I wrote the manuscript. And to my parents, Jimmy and Liz, whose love and support over the years have been a constant source of encouragement and inspiration— thank you.

DREAM WITH ME

The Drawings of Christopher Wilmarth

For those without an interior life or without an access to it my work, at best, remains on the level of "beautiful" and can give no more. The rest, which is the most, is not released. For those with an "inside" it can go deeper, for my work does not spell out, nor does it illustrate, meaning. It is an instrument of evocation and requires as catalyst the soul of a sensitive person to engage its process of release, its story, its use. These "requirements" in themselves do not contain prerequisites of exposure to nor education in art. If you can dream, whoever you are, dream with me.[1]

AT HEART, CHRISTOPHER WILMARTH (1943–1987) was an unashamed romantic. Describing the cool, cerebral detachment and impersonal fabrication of minimalism as "like walking into a brick wall,"[2] Wilmarth sought to express in his sculpture a sensitivity to the emotive power of light and shadow that is both pictorial and painterly. Remarkably, he did so through the use of heavy industrial materials such as glass and steel, and from these obdurate media he elicited works not only of enthralling formal beauty and sensuousness, but also of a highly personal and profound poetic sensibility.

Without being literally descriptive of such, his work sought to evoke a human presence and a sense of "place." Wilmarth wrote in 1974: "[I]t was the feeling of people in places and the special energy certain places have long after the people have gone that

provided insight into my concern with the figure. The configuration, scale and proportion of place can evoke human presence. These are the places I speak of when I say my sculptures are places to generate experience. The feeling is intimate. You are acknowledged."[3] For Wilmarth, light, and its attendant shadows, proved to be the perfect metaphor for these moments of reflection, and glass the ideal medium to capture them. "My sculptures are places to generate this experience compressed into light and shadow," he stated, "and return them to the world as a physical poem."[4]

A key to the success of Wilmarth's work was his astonishing grasp of the possibilities of drawing. As conventionally defined, sculpture and drawing offer two very different perceptual experiences: a sculpture is a work of art that exists in three-dimensional space, while in a drawing, volumetric form is established by illusory means. Despite this fundamental difference, as artists in the late 1960s began to question the materiality and primacy of the art object, so the intersection between drawing and sculpture became a remarkably fertile area for exploration and study.[5] Bound by no formal requirements or hierarchy of method, drawing's flexibility as both a technique and philosophy provided artists with a means to challenge existing paradigms. As the concepts of drawing began to merge with sculpture, and vice-versa, drawing became quite literally, in the words of Richard Serra, "another kind of language,"[6] one that was defined not by physical characteristics of support (paper) and medium (graphite, ink, etc.) but by a certain visceral response or intuitive feeling. As Robert Motherwell wrote in 1970, "[T]he instant one tries to define drawing, one finds that no one has been able to, that one is led to the same question quite rapidly, 'What is not?'"[7]

Wilmarth's own works reflect how the traditional distinctions between drawing and sculpture became blurred and, ultimately in his case, erased altogether. Like any sculptor, he thought in three dimensions, visualizing his complex forms in the round. Understandably, therefore, many of his preparatory studies took the form of three-dimensional paper maquettes or plywood mock-ups. For the most part, drawing was a retrospective activity for Wilmarth, a means for him to return to and assess specific aspects of existing sculptures, occasionally years after their completion. Acting almost like an appendix or index to the sculptures, his drawings helped mediate the transition from one sculpture, or group of sculptures, to the next.[8] With a notably consistent progression, the works build inexorably upon one another, each generating and nourishing the next layer.[9] The process and vocabulary of drawing, however, were also imposed by Wilmarth on the real space of his three-dimensional works as he expanded the parameters and possibilities of drawing in genuinely innovative ways. Most extraordinary is the group of drawings that he made in the early 1970s, not with pencil and paper but with etched glass, which acts as the drawing layer, and steel cable, the calligraphic surrogate for the graphite mark.

Wilmarth's work transcends straightforward categorization by medium, and, like that of other artists who acknowledge no peers and whose allegiance is only to their personal vision, has never been easily accommodated in the art world's narrow and neatly defined movements. This exhibition and catalogue revisit Wilmarth's artistic practice and compelling personal vision, in an effort to acknowledge his distinction as one of the most innovative artists of his generation. They seek both to underline

the sensitivity and vibrancy of his explorations in the realm between two- and three-dimensional work, and to reveal how he brought drawing and sculpture together in a fascinating and radical dialogue. Above all, though, I hope they reveal how Wilmarth communicated through his works a "survival of spirit,"[10] and a "sense of what it is to live in this world, a sense of acknowledgement, of being."[11]

4.25.76

New York especially and particularly Lower Manhattan has been a friend, a source of poetry and my home since I arrived in New York in 1960 at the age of 17. I would visit buildings, bridges and places and talk to them. Many realizations and epiphanies constantly occurred in the first few years. Cooper Union was and is another great friend. I loved my self for the first time I could remember and my streets and school loved me back. It was wonderful.[12]

In 1960, at the age of seventeen, Wilmarth moved from San Francisco to New York to attend The Cooper Union for the Advancement of Science and Art. His years at Cooper Union were to prove happy and formative ones, but his most valuable teacher and source of inspiration was the city itself. As a student, he wandered the streets of downtown Manhattan, transfixed by the interaction of color and light across its water and buildings. This deep and abiding connection with his immediate environment led to work that, even in his student years, was intimately connected with a "sense of place."[13]

One of those places was the viewing platform of the Queensboro Bridge. From there, Wilmarth watched the play of light across the water and the city, and dreamed. As he later recorded, his experiences on the bridge in October 1960 proved to be an epiphany, revealing to him what the subject of his art should be: "Maybe what happened there was the first time I could see it (the subject). It was not really a visual experience though or one of description (words). It was a feeling."[14] Reminiscing in 1984 to Dore Ashton about his early work, Wilmarth described that "feeling" as being concerned with "sadness, nostalgia, energies lost, the sweetness of certain decay, the buildings and all the people who had ever been there, the repressive aspect of groups and societies, the question of how the individual spirit could survive."[15] The intimate connection that he felt with lower Manhattan's light and buildings—with the "poetry of their walls"—was heartfelt and genuine. The slow but inexorable gentrification—"exploitation" in his own words—of the area pained him as all that he loved began to lose its soul and individuality. Anthropomorphizing the cityscape, he described in 1976 how "the light has become fitful and neurotic. The buildings and lots have become uncomfortable in their place. They shift and think of doom. The buildings don't trust anymore."[16]

In 1963, Wilmarth explored these feelings for the first time through a series of twenty-two consecutively numbered drawings entitled the Platform Dream series. He described how the subject matter of the drawings "felt like places, but like the places in my head. They

didn't look like anything outside." In each work, such as *Platform Dream #5* (cat. 1) and *Platform Dream #11* (cat. 2), the fragments of his dreams are framed by the brilliance of the cream prepared paper, redolent of the exact moment of his reverie when "the light would change as if another layer of brightness had bloomed around me."[17] Although far from literal, parallels do exist between the imagery of some of the Platform Dream drawings and the sculptures and photographs that he was making at the same time. The bold V-shaped mark at the top of *Platform Dream #11,* for example, is a motif common to a number of contemporaneous works and stems from a series of photographs he took in 1963 of downtown warehouses.[18] Other imagery, such as the elegant sculptural form that extends up from the bottom of the sheet in *Platform Dream #5,* is reminiscent of his early Brancusi-inspired unadorned carved-wood sculptures, such as *Her Sides of Me* (1964) and *In Edges* (1964), which is no longer extant.[19] As student work, the Platform Dream drawings are as much about learning to compose a surface, about the fluidity of movement across a page and the sensuousness of line, as they are indicators of Wilmarth's early epiphanies of place and spirit.

Besides the Platform Dream drawings, Wilmarth affirmed and preserved only one other significant body of work from the early 1960s[20]: a group of drawings of Susan Rabineau, whom he met at Cooper Union and married in 1964. Most striking about both groups is their creative engagement with the art historical past. Wilmarth did not judge history as irrelevant to contemporary issues, but instead considered "history and time as continuously generating layers. The past is nourishment and support for the present: A gift with these conditions; help yourself but add your own."[21] The composition and technique of his figurative drawings, for example, are clearly inspired by Matisse's charcoal figure studies from the 1930s and 1940s. The latter are distinguished by fluidly rendered lines and a luminous shading obtained from stumping the charcoal to a soft sfumato quality such that their subjects slip into the light of their surrounding space through delicately defined tonalities. Just like Matisse, Wilmarth sought to capture the qualities of brilliant light and express it through what Matisse called an abstract "spiritual place."[22] And ironically, neither found this place until they set foot in New York.[23]

The exquisite tone and facture of the charcoal in drawings such as *Shifrah* or *Yolande* (cats. 3, 4) mirror the shimmering charcoal surfaces of Matisse's drawings. That Wilmarth depicts Susan's head either as a blank ovoid shape or not at all suggests that establishing a psychological relationship between sitter and viewer in these works held little interest for him.[24] Instead, through these beautiful and sensual drawings he explored the abstract beauty of the human form and issues of structure, space, surface, and scale. He reveled in the sheer joy of line, a line that could be abstracted, in works such as *Yolande,* to the point where the subject—in this case the lower torso and right leg—becomes almost unrecognizable. That these works are ultimately derivative of Matisse is the least important fact about them. What distinguishes them is how Wilmarth assimilated and absorbed the lessons of Matisse in ways that refreshed the past, so that his work was never atavistic, but irrefutably always his own. Even at this early stage of his career, he strove to render light with a poetic rather than formal interpretation and to create compositions of remarkable clarity and honesty.

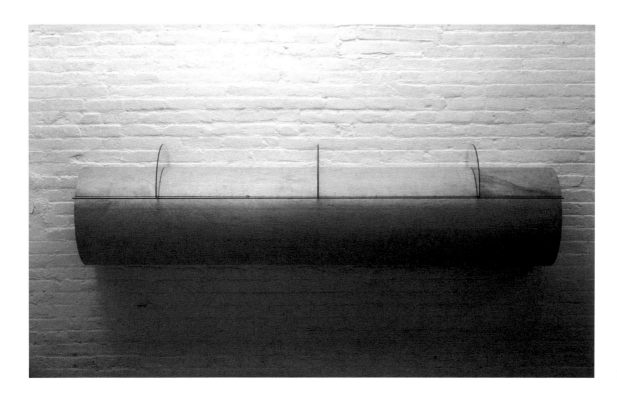

Fig. 1. *Cirrus,* 1968. Glass and birch plywood; 62 x 239 x 39 cm. Collection of Susan Wilmarth-Rabineau, Courtesy of Robert Miller Gallery, New York.

For as long as I remember I would tell stories to myself and make magic. Only I didn't think of it that way: I never thought that I lived in my head. I was always on the lookout for a place with the light just so and the colors right (red and yellow almost never seemed right) and if I was quiet, or hummed a long time just one or two notes, that I would become transparent and be a part of the place I was in. Then I could talk to the trees or a special corner. It felt nice so I did it a lot.[25]

A critical turning point for Wilmarth came in 1967 when, for the first time, he introduced glass into his sculpture. The following year, at his first solo exhibition at the Graham Gallery in New York, Wilmarth exhibited a number of works in which he juxtaposed cylinders and wedges of highly polished birch with sheets of tempered glass.[26] His use of glass in works such as *Cirrus* (fig. 1) or *Lit* had been prompted by his construction of a glass and wood cabinet in 1966,[27] and the ensuing discovery that glass was the one medium that could truly express "the feeling <u>one</u> gets in certain places when the configuration and identity of objects, the quality of time and light and one's position in relation to this place (psychological) merge in (for) a (spiritual) significant (human) moment."[28] He discovered that the atmospheric translucence of glass allowed him to capture through light the essence of these "revelations" and "epiphanies" of place and spirit.[29] In calling sculptures such as *Cirrus* his "first light pieces," works that "have a lot to do with light without containing light sources within

themselves," Wilmarth affirmed a course that he was not to stray from for the rest of his career.[30]

Wilmarth approached the use of glass with an entirely open mind. He visited local manufacturers to learn all he could about its physical properties and compositional possibilities. By 1969, he had begun to make sculptures from glass alone, using gently bent and curved sheets to create complex interlocking floor sculptures such as *Gye's Arcade* (now in the Corning Museum of Glass) and the multiple-pieced *Go* (no longer extant). Excited by these early efforts, Wilmarth began to experiment with the expressive possibilities of drawing, not on paper, but on small squares of etched blue-green glass.

At first, it might seem hard to reconcile works such as *Shady Gibson* (cat. 35) or *Crosscut Drawing* (cat. 34) with traditional notions of draftsmanship. Yet despite their apparent unconventionality, Wilmarth's glass drawings are remarkably conventional in a number of fundamental respects. As medium and support, the glass acts as the equivalent of a sheet of paper, upon which he used the elements of contour, line, tonal value, and planar perspective. As to their role in his artistic process, many of these glass drawings fulfill drawing's functions as not merely a means to illustrate, but a vehicle to think, question, and speculate as Wilmarth began his investigation into the elements of the pictorial vocabulary that he was to use in his larger-scale sculptures.

Drawing, 1970 (cat. 31), is one of Wilmarth's earliest glass drawings. One is immediately struck by an extraordinarily indeterminate and atmospheric internal space, and a muted, almost other-

worldly light emanating from within the square of solid inch-thick glass. These ethereal effects are largely the consequence of Wilmarth's discovery that by etching the surfaces and edges of the glass with hydrofluoric acid, he could, in his own words, both "pull" the sublime blue-green color of the glass to the surface and control the exact degree of its transparency.[31]

Using this simple technique, Wilmarth created works of astonishing complexity that fulfilled his desire to make art "that is (contains) like (all) the expressions of a face."[32] The alembic effects of the acid are startling. Wherever the acid is brushed onto the glass it causes the surface to frost over, allowing Wilmarth to control the viewer's access into the work. The exquisite icelike effect[33] recalls the beautiful passages of stumped charcoal of his Platform Dream and figurative drawings. Because Wilmarth did not apply the acid uniformly, etched areas are juxtaposed against completely transparent ones. As we pass in front of the work, the result is a play of light and shadow within, around, and across the work as the etched surface simultaneously conceals and reveals the space within the glass. Together with the opalescent graphite marks on its surface, the etched areas activate the work with an astounding vitality. With prodigious skill, Wilmarth makes the importance of time, movement, place, and person inherent to these small-scale works.

Although *Drawing* consists of just one sheet of glass, in many of the subsequent glass drawings Wilmarth explored increasingly delicate and subtle nuances of atmospheric space and translucency by layering sheets of differently etched glass over one another. In order to attach the sheets together, the artist discov-

ered a perfect solution in Roebling steel suspension cable. This, he realized, could be used for both structural and calligraphic purposes. The wire's natural contour and linearity act as a surrogate for a traditionally drawn line, and its presence helps to heighten the sense of planar perspective within the works by focusing attention on the illusory and real experience of depth within the glass panels. In *Untied Drawing* (cat. 33), for example, as we follow the fluid contours of the cable weaving its way in long vertical patterns under, through, and over the top layer of glass, the cable not only serves as a drawn line but also helps demarcate the three-dimensional pictorial space of the piece.

The effects of the steel cable and the multiple plates of glass in works such as *Crosscut Drawing, Untied Drawing,* or *Tied Drawing* (cat. 32) are as beautiful as they are startling. The two latter works share a tripartite structure. In *Tied Drawing,* three sections of rough-edged glass are held in place by nine loops of cable that hook each of the glass sections to an underlying sheet of glass. The effect of the light as it is caught within the cracks of space between each of the three top panels is mesmeric. In *Untied Drawing,* however, Wilmarth used only two sheets of glass, the upper layer held in position a couple of inches below the bottom one, thus creating bands at the top and bottom of the work where the glass is just one sheet thick. The shadow cast on the wall by the bottom of the upper sheet further heightens the tonal and translucent distinctions. The cut-away edges of *Crosscut Drawing* appear at first radically different, until one realizes that by turning *Untied Drawing* on its side, the pattern of the wires as they weave their way over and under the glass mirrors that of the cut-away sheets of glass in *Crosscut Drawing.*

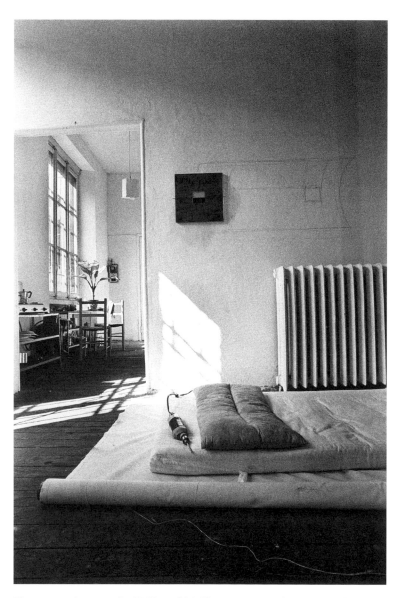

Fig. 2. 1973 photograph of Wilmarth's Milan apartment showing a wall drawing (above the radiator). Fogg Art Museum, The Christopher Wilmarth Archive, gift of Susan Wilmarth-Rabineau, CW2001.888. Photo by Enzo Nocera.

A small number of the glass drawings more obviously explore sculptural space. In *Shady Gibson*, for example, a delicately arched and etched sheet of glass is held in place by a taut cable that extends out from under the glass in the same proportions as the glass sheet. The cable acts as both support and visible wall drawing, the latter, as a photograph from 1973 of Wilmarth's apartment in Milan reveals, something that he did make very occasionally with graphite when investigating questions of scale (fig. 2). As Wilmarth described in 1971, everything in these small-scale works, such as *Shady Gibson*, is revealed, nothing hidden: "[I] got disenchanted with the whole idea of fabrication, of making pieces in which all the structure wasn't visually evident. I wanted it all to be out there. Now there are no mysteries—the fastenings are an integral part of the piece.... You hang the piece up with the piece."[34] A fascinating dialogue is set up between the tensile strength of the steel cable flattened against the wall as a sharp-edged plane and the delicacy—and, of course, vulnerability—of the rounded glass sheet. As the constantly shifting light falls across and beneath the surface of the bent glass, so the cloudlike forms etched on both sides of its surface seem to float in free space and the physical substance of the glass appears to dissolve into ethereal shadow. Studies in balance, gravity, and weight such as *Shady Gibson* extend in thought-provoking and hitherto unexplored ways the possibilities of drawing.

I do not want to get involved in trendy movements ... but to share my vision of the world around us with as many people and in as direct a way as possible.[35]

As independent works, Wilmarth's glass drawings reflect the increasingly common tendency among artists of his generation to shift drawing from its introspective role as a preparatory tool to a medium that no longer had a status secondary to painting or sculpture. Throughout the 1960s and 1970s, though, drawing also continued to be a fully intuitive and active part of the creative process, a means to explore new imagery and generate original pictorial ideas for work in other media. The drawings Wilmarth made in this vein are relatively modest and contained largely within his sketchbooks. As private and revealing as a diary, the musings and speculations in these sketchbooks provide the most intimate access and insight into Wilmarth's thinking process.

The surviving sketchbooks date from throughout Wilmarth's career. The earliest, dated 1961, is a careful record of notes and projects undertaken for a course on two-dimensional design at Cooper Union (cat. 23). The latest, a small spiral-bound notebook, is dated 10/87 (cat. 30), just one month before he took his own life on November 19, 1987. Just as a diary provides its owner an opportunity to think aloud in absolute privacy, so Wilmarth's sketchbooks allowed him to rehearse ideas in free space, without expectation or public scrutiny. The sketchbooks contain a remarkable range of material. A number from his college years are carefully handbound (cat. 24), with some of these containing beautiful exercises in calligraphy.[36] A few include candid observations and writings that were never published, as well as notes on the technical aspects of making the sculptures.[37] Others capture the intimacy of when Susan modeled for him (cat. 25). As a place for creative potential and speculation, they also reveal Wilmarth working out

ideas through rapid and spontaneous sketches, the work of art slowly transformed before our eyes as he moves from draft to draft in a visual chain of thought. Drawn either in black ink or graphite, many of these sketches are so abbreviated and modest that they seem to be quite literally the embodiment of the most fleeting of emotions and thoughts (cats. 17, 30). Above all, though, they also contain the only visual records of dreams never realized.

Perhaps most revealing in this regard are the drawings from the four sketchbooks (cats. 27, 28) for the most significant project in which he was invited to participate: the design for the American Merchant Marine Memorial.[38] In a proposal dated May 14, 1987, Wilmarth laid out an audacious and ambitious design for the memorial to all the merchant marines who had been lost at sea. "I see a Memorial," he wrote, "not as an object, though objects can be engaged, but as a place. A place where people are moved to a state of Epiphany, a realization of a sense of universe, a sense of life's mysteries and that death so physically final, is not so in spirit, as we can, if we allow, reach back to the beginning of time, as we ourselves slowly create our own layer for the future to hold."[39]

The plan called for a fifteen-to-twenty-thousand-square-foot Island of Memory or Remembrance to be constructed over Diamond Reef, just off King's Point on Governors Island between lower Manhattan and Brooklyn. The memorial was to be 360 feet long and 72 feet wide and approached by a long granite staircase that arose out of the sea. To be inscribed on the steps were the names of the thirty American ships that had been lost with all hands during World War II, the names appearing and disappearing from view with the level of the tide. The names of the sailors who

perished were to be listed on the everdure bronze walls flanking the staircase, at the apex of which was the Vessel of Souls. An oval forty-eight feet long, its floor would have been either illuminated glass or black granite. Its walls were to be a combination of etched glass and everdure bronze, upon which would have been placed nine cast glass and bronze "souls" and a memorial to the unknown mariners. Exit from the Vessel of Souls was via a gently sloping ramp. The extraordinary scheme was, in many ways, the ultimate expression, on paper at least, of all that Wilmarth had worked toward in his sculpture: a place to enter into, to be physically, psychologically, and spiritually a part of, in order to experience release and epiphany.

However, for any sculptor who must envision and understand physical mass, volume, and space in three dimensions, drawing on a flat two-dimensional surface can be both limiting and frustrating. Wilmarth himself noted, "I don't think it is possible to present a sculpture in drawing form, and really to be able to understand it."[40] For that reason, in order to explore the spatial and volumetric concerns of a proposed sculpture, Wilmarth tended to eschew preparatory studies on paper in favor of building plywood mock-ups and miniature paper and card maquettes. Six models survive from the late 1960s in which Wilmarth integrated two- and three-dimensional elements. Most consist of a platform upon which a miniature wood and plastic maquette of the sculpture is placed. On the board behind the model are graphite drawings related to the sculpture. In each of these pieces, such as *Left* (cat. 5), *Her Sides of Me* (cat. 6), and *Reach* (cat. 7), Wilmarth carefully and consciously combined, and preserved, a record of his preparatory process: the most rapid and animated

of drawings joined, quite literally, with the three-dimensional model that resulted from these initial ideas. Why he decided to mount the models and drawings together is unclear, but their prescience in heralding the combination of drawing and sculpture in his later glass drawings cannot be ignored.

The majority of Wilmarth's maquettes are really three-dimensional drawings, replicating with card stock, staples, and graphite the qualities of the proposed sculpture (cats. 8–16).[41] Small enough to hold in the palm of the hand, the maquettes provide an immediate sense of the whole sculpture, and Wilmarth used them to convey to the fabricators at the steel foundry a clear sense of his intent. The care, and evident delight, taken in the making of these maquettes is visible in many of the surviving pieces. Some, such as *Maquette for "Alba Sweeps"* (cat. 11) and *Maquette for "Orange Delta for A.P.S."* (cat. 8), were signed and dated by Wilmarth, who clearly considered these sculptures in miniature works of art unto themselves. A comparison between the final maquette for *New Normal Corner* (cat. 14) and the actual sculpture (fig. 3) highlights how beautifully Wilmarth evoked the qualities of steel and etched glass from just the natural opalescence of a graphite pencil. The maquettes for *New Normal Corner* (cats. 12–16) reveal Wilmarth's process of thinking as he worked through various possibilities for the placement of the glass and steel, a parallel to the same process in one of his sketchbooks (cat. 17). One of the maquettes for *New Normal Corner* (cat. 16), in which the dimensions of the piece are added to the edges of the paper, relates closely to the technical specification sheet that Wilmarth also drew for the steel manufacturers (cat. 18). The majority of the surviving maquettes date from the early 1970s; from 1974 on,

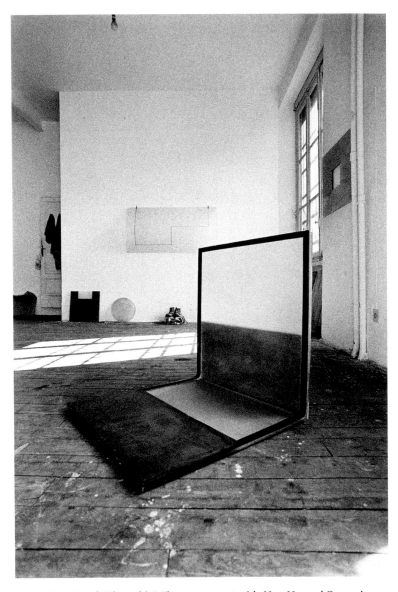

Fig. 3. Interior of Wilmarth's Milan apartment with *New Normal Corner* in foreground, 1973. Fogg Art Museum, The Christopher Wilmarth Archive, gift of Susan Wilmarth-Rabineau, CW2001.890. Photo by Enzo Nocera.

Wilmarth appears to have relied largely on plywood mock-ups rather than the small-scale maquettes.[42]

Although Wilmarth involved himself at all stages of his sculptures' production, often working alongside the factory workers who cut and bent the steel and glass sheets, he also made carefully formulated instruction and specification drawings that could be used for reference by the workers.[43] His meticulous technical drawings open a fascinating window into his preparatory process. But the drawings, such as the sequential series for the maquette of *Calling* (cats. 19–22), also reveal, perhaps more immediately than the sculptures themselves, how he was able to create works of marked visual complexity with the simplest of means.

In 1974, Wilmarth began work on a glass and steel maquette for *Calling* (figs. 4, 5), a sculpture he proposed for the grounds of the Society of the Four Arts in Palm Beach, Florida.[44] Although he did not receive the commission, in 1975 he embarked on the full-scale version, completing the sculpture in the following year. Using some of the standard forms of architectural drawings to realize the sculpture from every angle—in section, elevation, and plan—the specification sheets for the maquette demonstrate Wilmarth's skill in suggesting complex and multiple variations in configuration depending only from where the sculpture is viewed. Yet, it is also striking how simple the basic elements of the sculpture are: just one plate of glass and one of steel. The instructional drawings show how the steel plate was bent so that it cocoons the central glass panel, but in such a way that it still retains "a memory of the germ—the first shape—a simple rectangle." The effect, as one walks around *Calling*, is of a sculpture continually evolving in form, as if endowed with "a sense of expectation"[45] and palpably "living."[46]

Art exists for a reason. The reason is simple and often forgotten. Art is man's attempt to communicate an understanding of life to man. To give in a sculpture what I understand; to imbue concrete things with parallels to human feelings; to do this in a real way; to be believable is my purpose.[47]

It is apparent from the dates of many of his drawings that Wilmarth often undertook the drawing process after a sculpture

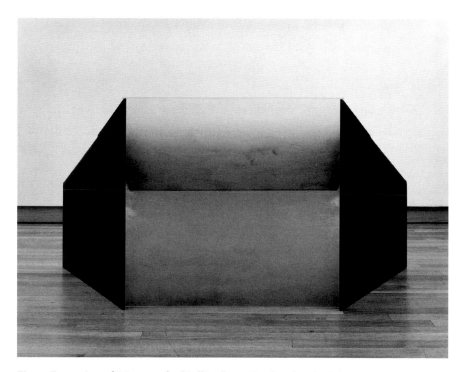

Fig. 4. Front view of *Maquette for "Calling,"* 1974. Steel and etched glass; 61 x 122 x 61 cm. Private collection, San Francisco. Photo by Jerry Thompson.

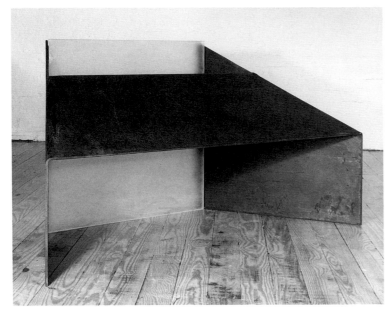

Fig. 5. Back view of *Maquette for "Calling,"* 1974. Photo by Eric Pollitzer.

had been finished. A perfect example is a series of watercolor drawings from 1975 of *Wyoming* (cat. 26), a sculpture made in 1972 (fig. 6). Drawings such as these allowed Wilmarth to revisit the finished work in order to re-explore ideas manifest within the sculpture and to pose afterthoughts and suggest corrections. They allowed him to bring an existing sculpture, sometimes years after it had been completed, to a heightened realization, and ensured a continually evolving connection between his older and newer work.[48]

This desire to rework through his drawings the effects that he sought in three dimensions with glass and steel led to many of Wilmarth's works on paper being ambiguously situated between sculpture and drawing. In *Black Clearing #4 for Hank Williams* (cat. 37), for example, we experience not just illusionistic recession but real space itself. By creating the drawing out of multiple layers of thick watercolor paper stapled together, and then cutting

through those layers at the center to approximate the sense of depth and spatial recession evident in his sculptures, Wilmarth turns the drawing into a plastic entity, reminiscent of his earlier glass drawings.

Four drawings related to the maquette and sculpture of *Calling* illustrate the range of Wilmarth's draftsmanship. In both sculptures, a continually shifting light collects in the space between the etched glass and the enveloping matte black steel, so that the surface of the glass becomes animated from within. As subtle nuances of light and shadow play across its surface, the steel immediately behind the glass becomes a ghostly shadow of its former self. That the experience is more pictorial than sculptural is reflected in the related drawings. Of the four drawings, two—*Drawing for "Calling"* and *Three Drawings for "Calling"*—were made in conjunction with the 1974 maquette. The others were made after the full-scale sculpture had been completed.

In *Drawing for "Calling"* (cat. 40), Wilmarth portrays the sculpture directly from the front. Silhouetted against white wove paper, the drawing consists of multiple sheets of translucent vellum paper that have been cut and then stapled in the shape of the sculpture. The layering and incisions into the paper allowed Wilmarth to establish a sense of the real space and structure of the sculpture: at the center, an etched glass panel is flanked on either side by a black steel sheet, part of which folds around to run behind the top of the glass (fig. 5). Not only does the vellum paper recall the glass panel's atmospheric translucence, but by varying the density of the opalescent graphite and applying delicate scumbling, Wilmarth also alludes to the painterly effects of the etched glass

surface. He achieves an extremely haptic quality reminiscent of the sculpture itself as he captures the qualities of the steel and the glass, and even the sense of the dark shadow of the steel as it passes behind the upper part of the glass panel.

The three small drawings that Wilmarth mounted together in *Three Drawings for "Calling"* (cat. 39) focus more on capturing the sculpture's luminosity. Each is made on several sheets of heavy white wove watercolor paper. With the outline of the sculpture established in graphite, Wilmarth cut areas of the paper away to demarcate literal space within the drawing, which in turn approximates both the actual space of the sculpture and the illusionistic space behind the seductive sea-green glass surface. To suggest the play of light and shadow across the sculpture, Wilmarth exploited the natural luminosity of the pristine white sheet to evoke light, and brushed on delicate and subtle watercolor washes to indicate the shimmering surface of green glass and the gray shadow cast by the steel.

Increasingly, Wilmarth's drawings became less literal and more ambiguous and oblique. This shift from description to evocation becomes apparent in the two drawings made after the full-scale sculpture of *Calling*. In the small-scale drawing made on brown paper (cat. 41), Wilmarth focuses on the sculpture's three-dimensionality, the cuts into the paper deep and clearly visible. In the second drawing (cat. 42) he treads a fine line between abstraction and representation, evoking the lambent qualities of light and shadow across the sculpture and its surrounding space through the most evanescent and poetic of means: the fluidly rendered edges and shimmering contours of the sculpture appear to fade

away through nuanced shadow into the background of the drawing. The soft-edged and ambiguous tonalities of the drawing mimic the effects of raking light against the edges of the sculpture's glass as they dissolve into the deep shadows that the glass and steel cast. Although Wilmarth had not yet discovered the quiet beauty of Stéphane Mallarmé's poetry, which directly inspired later works, drawings such as *Calling* and *Invitation #1* (cat. 38) are reminiscent of Mallarmé's desire that language should not reveal but veil, that objects should not be described literally but be expressed allusively through their emanations: "The ideal is to suggest the object ... [which] must be gradually evoked in order to

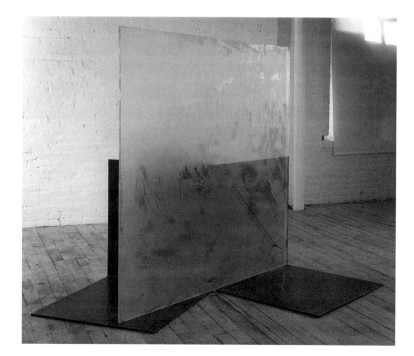

Fig. 6. *Wyoming,* 1972. Steel, etched glass, and steel cable; 153 x 147 x 186 cm. Estabrook Foundation, Carlisle, Mass. Photo by Eric Pollitzer.

show a state of soul," Mallarmé wrote in his essay "The Evolution of Literature."[49]

There have been times in my life when the work of writers and poets has changed the way I perceived myself and the world, or has provided an inspiration for my art as with seven poems of Stéphane Mallarmé. With Mallarmé understanding him was like a realization, an epiphany in that I found something of myself in them…. When I realized that for Mallarmé his reverie and imagination were more real than the world outside, than even the woman beside him; that in his work is a sense of longing for experience not fully realized; when I recognized this, I found another place, in pages, for dreams.[50]

In late 1978, Wilmarth was asked by the poet Frederick Morgan to recommend someone to illustrate a book of his translations of seven poems by Stéphane Mallarmé. Wilmarth was so struck by Mallarmé's melodious and philosophical poems that he asked Morgan whether he could take on the task himself. It was a project that was to have fundamental conscquences for his work. "Poetry," wrote Mallarmé, "is the expression of the mysterious meaning of the aspects of existence through human language brought back to its essential rhythm: in this way it endows our sojourn with authenticity and constitutes the only spiritual task." Through

incantation and the music of words, Mallarmé sought Beauty and the transcendent Ideal, to restore "the Orphic explanation of the earth."[51] Mallarmé conceived of poetry as a means to transform the prosaic language of everyday into a language and a world that was eternal and sacred, and to offer passage to that dimension. Intuitively, Wilmarth had already moved toward Mallarmé's youthful vow to "Describe not the object itself, but the effect it produces,"[52] and the poems that Morgan gave Wilmarth merely heightened his desire to seek within his work a poetry of spiritual and interior reverie.

Wilmarth took on the project while he was a visiting lecturer in the Department of Art Practice at the University of California, Berkeley. Susan Wilmarth-Rabineau remembers, "He spent weeks trying to understand the poems, making drawings, searching for images that would be equivalent to the poetry."[53] It was not until he began moving his arm with a "different rhythm"[54] while sketching some dishes in the kitchen of the apartment that he was renting, that he suddenly came to the realization that "'This is a guy who just lives in his head!'"[55] Using that metaphor as the key, Wilmarth settled on the image of an oval sphere to translate the poetry of Mallarmé.[56] For each of the seven poems, he took advantage of the many metaphorical connotations of the oval as heart, soul, or mouth, to make a series of drawings first in charcoal, then in pastel.

Each drawing alludes to the metaphorical richness and spiritual essence of its namesake poem. Mallarmé wrote the first, "When Winter on forgotten woods moves somber…," in 1877, in memory of a friend's wife, who had died. Wilmarth evokes the lost soul of

the elegiac poem through a literal absence in the drawing (cat. 43): a small, oval shape removed entirely from the top layer of paper. In *"The whole soul summed up ..."* (cat. 45), Wilmarth concentrates on the musical beauty of the first stanza: "The whole soul summed up / when slow we breathe it out / in several rings of smoke / giving place to other rings."[57] Closely related to the imagery of "Sigh," a poem Wilmarth experienced as "a yearning for a spiritual state; a sweet, painful anguished yearning for another state of being,"[58] the release of breath and the soft diffusion of the smoke in *"The whole soul summed up ..."* is quietly and subtly evoked in drawing through a series of outer rings that dissipate out from the central oval.

In both of these resonant drawings, Wilmarth carefully rubbed the pastel across the surface of the heavily textured paper until its powdery quality was transformed into a rich velvety surface. By using pastel Wilmarth introduced color, an element he had used sparingly in previous drawings. Color held symbolic meaning for Wilmarth, as it did for Mallarmé; for both, the deep and luscious azure blue tones Wilmarth used in *"When Winter on forgotten woods moves somber ..."* epitomized the vastness of the sky, as well as escape and freedom. The rich red hues of *"The whole soul summed up ..."* allude to the "Bright kiss of fire" in the poem's second verse.[59]

Mallarmé wrote the hauntingly beautiful poem "Saint" in December 1865:

> At the window harboring
> old sandalwood losing its gilt

> of her antique lute that sparkled
> once with mandola or flute

> stands the pallid Saint, displaying
> the old volume opened out
> where once at vespers and compline
> rustled the Magnificat:

> at this stained-glass monstrance, brushed
> fleetingly of a harp formed by
> the Angel in his evening flight
> for the finger's delicate ply

> which, without old sandalwood
> or ancient book, she balances
> above the instrument of plumes,
> musician of silences.[60]

Divided by the colon, each half of the poem begins with an image of glass: In the first half, a window; in the second, a monstrance, used to keep the host during vespers and compline, where once Saint Cecilia's music could be heard. The sense that glass provides an opening, a means of passage through to something else, is as central to Mallarmé's poetry as to Wilmarth's art. Through those windows we watch the passing of time itself, each musical image alluding to the transformative power of art as one by one the instruments are silenced. In the charcoal drawing of the poem (cat. 44), Wilmarth uses the inherent qualities of the medium to create seamless transitions of tone. Taking advantage of how even the gentlest rubbing can erase the almost weightless particles of

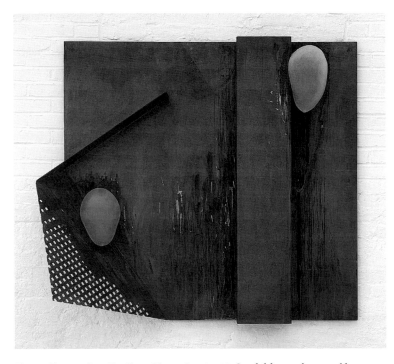

Fig. 7. *Emanation (For Enzo Nocera)*, 1983–86. Steel, blown glass, and bronze; 122 x 132 x 46 cm. Estabrook Foundation, Carlisle, Mass. Photo by Jerry Thompson.

charcoal, Wilmarth reveals the heavy texture of the underlying paper by gently removing the topmost layer of the charcoal. The central oval, defined by nothing more than exquisitely nuanced tones in the charcoal, is pierced by a slender, sharp triangle, formed from a cut in the top layer of paper. Its open form evokes the openings suggested within Mallarmé's own windows into the void. As a container of the opening, the oval recalls the monstrance, the triangle its host. More poetically, it suggests the sharp silence that pierces the end of the poem.

Realizing that blown glass would express sculpturally the images he had drawn for Frederick Morgan's book, Wilmarth became a frequent visitor to the Oakland workshop of glassblower Marvin Lipovsky.[61] Shaped by human breath, blown glass literally captured the "human presence in non-objective art"[62] that Wilmarth had always sought. The impact on his work was profound. From 1979, the forms in his sculpture moved away from the pure geometry of his earlier work toward a more organic imagery that incorporated haunting spheres of blown glass, which he considered "physical representations of states of mind, reverie, interiors, spirits."[63] These intimately sized sculptures mirror the drawings closely, and as with his earlier sculpture, they generated a number of watercolor studies that capture the play of light and shadow across the front and edges of the frosted spheres (cats. 46–52). Together with a series of prints, the poems and drawings were published in 1982, and later exhibited, under the title *Breath*.[64]

He said he was tired of hanging on to old ideas about himself. He tries to be a crustacean, but he isn't really. Everything layers up on him. If it didn't, I think he would be bored—he has to live it all at once. He tries to step away—to escape, but I don't think he really wants to. It's all his own story.[65]

In 1983, following the Breath series, Wilmarth began work on a group of large-scale sculptures that were completed in 1986 and exhibited in the same year at Hirschl and Adler Modern in New York.[66] Evoking the "layers" of his previous sculptures, these new

works combined in an organic whole the rigorous geometry of his early sculptures with delicate blown-glass spheres. In *Emanation (For Enzo Nocera)* (fig. 7), a tribute to the photographer Wilmarth had met in Milan in 1973, two glass "heads" are placed in niches on the richly patinated, gouged, and sanded steel and bronze surface of the metal structure. Both "heads" seem imperiled, one sheltering within an open-mesh flap, the other a ghostly sphere peering around a vertical protrusion, apparently ready to detach itself from the sculpture and escape. The brooding and emotive power of these sculptures was expressed even more directly in the work that Wilmarth started in what tragically proved to be the last year of his life, 1987.

In these last months, Wilmarth immersed himself almost exclusively in the act of drawing. Made in two distinct groups, these works on paper are among the most abiding, moving, and profound works of his career. The intimately scaled *Twelve Drawings for the Forty-fourth Year* (the title refers to the artist's age) preceded a second group of drawings that Wilmarth was working on immediately before his death. The latter drawings are considerably larger both in scale and number, and, for the first time since the works in the 1963 Platform Dream series, are made on single sheets of paper without any layering or cutting away. Both groups return full circle to his earliest works: not only is their technique quite similar to the Platform Dream drawings—mostly graphite on paper prepared with rabbitskin glue and gesso—but as with his Matisse-inspired figurative drawings of some twenty-three years before, Wilmarth once more engages the art historical past, this time through the connection of his "heads" to Brancusi's *Sleeping Muse,* as well to the remoteness of Giacometti's isolated figures.

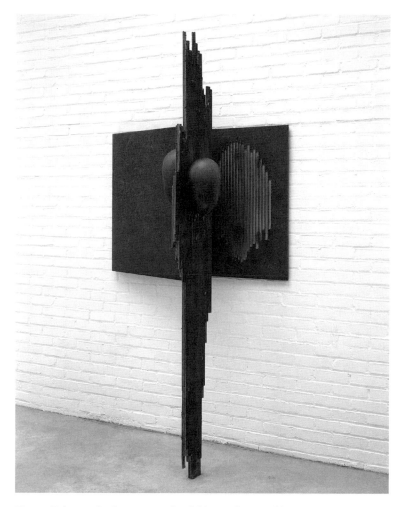

Fig. 8. *Delancey Backs,* 1983–86. Steel, blown glass, and bronze; 244 x 66 x 127 cm. Estabrook Foundation, Carlisle, Mass. Photo by Jerry Thompson.

Although among the smallest of Wilmarth's drawings, the *Twelve Drawings for the Forty-fourth Year* are also some of the most affecting and powerful. Drawn on layered paper, many of them have titles that recall those of previous sculptures. The imagery of some, such as *Twelve Drawings from the Forty-fourth Year, #12: Delancey Backs* (cat. 55), also bears close resemblance to that of their sculptural namesakes. Here, the two ghostly heads placed

on either side of a vertical divide parallel the structure of the sculpture *Delancey Backs* (1983–86; fig. 8).[67] The five gently incised rectangles on either side of the central axis only suggest openings—windows, perhaps—to an interior space that seems closed to the viewer. With *Twelve Drawings from the Forty-fourth Year, #2: Emanation (for Enzo and Me)* (cat. 53), it is the ripped, gouged, and cut surface of the top sheet that recalls the heavily textured and worked metal plates of the sculpture itself. The imagery of *Twelve Drawings from the Forty-fourth Year, #9: Moment* (cat. 54) returns to that of the Breath works depicting "The whole soul summed up…". Just as with those earlier drawings, a central ovoid shape is surrounded by a ghostly halo emanating outward. However, whereas the removal of the oval in the Breath drawing resulted in a palpable absence, as well as a passage into the unknown, in the 1987 drawing the oval, although cut out, was replaced in the final composition, preventing entry into the literal space of the work as it is made whole once again.

Common to almost all of the remaining 1987 drawings is a blackened sphere which, when read as a head or soul, makes explicit what had usually been only alluded to in his work: the manifestation of an individual spirit or mind, and above all else, his own figurative presence. In works such as *Untitled* (cat. 56), the dense graphite "head" is nestled within a framework that recalls the structural elements of earlier sculptures as well as a human shoulder. As the evanescent aureole around the oval diffuses at its edges to a ghostly absence, what is apparent and real seems to be transformed into an aura, from living being to transcendent soul. In *Untitled* (cat. 57), the vertical pattern of the underlying wash not only recalls the etched surfaces of his glass panels but also the

cover of his student bound book, *The Hunger Artist* (cat. 24). The evocation of a human presence in the work is once more no longer allusive. The blackened "head" at the right clearly rests upon shoulders, the head itself confined within claustrophobic bands of the gray wash, while in a moment of emanation two abstract sticklike figures appear to be walking out of the area of gray wash into the bright light at the left of the sheet.

The act of drawing is always one of self-projection as an artist expresses the most intimate thoughts and ideas.[68] It is all too easy to interpret the apparent anguish and haunting drama of these drawings as indicative of only Wilmarth's personal pain, and, inescapably, of his impending suicide. Yet, far from predicting a coming closure or an end, these works promise a sense of release that is fulfilling and powerful. More than in any previous works, Wilmarth found himself uninhibited by any emotive or personal strictures. Just as he felt free to bare his soul through a series of autobiographical interviews under the nom de plume Celadón in the catalogue that accompanied his 1986 exhibition,[69] so he was able to create these works without constraint or limitation. These very last works, along with the Platform Dream drawings that he began his career with in 1963, can be considered among his only truly independent works on paper: unfettered by direct connections to any one sculpture, they focus unwaveringly on the intensity of his own experience and his own personal reverie. It is hard not to see one of the most extraordinary drawings that Wilmarth ever made, *Untitled* (cat. 58), as a self-portrait. The almost evanescent quality of its graphite surface recalls the gray, molten lead-covered bronze head in the last sculpture that he was to make, *Self-Portrait with Sliding Light* (1987; Museum of Modern

Art, New York). What is palpable in the drawing is not anguish or pain, but its gripping and profound silence. Poetic to the last, the drawing is the ultimate expression of his lifelong search for that sublime space that could "evoke a spiritual disembodied state close to that of reverie."[70]

NOTES

A note on the Christopher Wilmarth papers, 1956–1987, Archives of American Art, Smithsonian Institution, Washington D.C., and the Christopher Wilmarth Archive, gift of Susan Wilmarth-Rabineau, Fogg Art Museum, Harvard University Art Museums.

In 1989, Susan Wilmarth-Rabineau donated to the Archives of American Art a selection of her late husband's original papers and other archival materials. These were microfilmed by the Archives of American Art and are now accessible on six reels of microfilm, reels 4293–4298. Prior to the gift, much of the material was duplicated so that Susan could maintain a parallel archive in her studio. A large quantity of original material had, however, not been made available to the Archives of American Art. This included, among other items, sketchbooks, notebooks, maquettes, technical specification sheets, materials and tools, personal correspondence, musical recordings, and childhood art. This material, together with the duplicated Archives of American Art papers, was donated by Susan Wilmarth-Rabineau to the Fogg Art Museum in 2001.

Within the essay notes, citations to archival material are given to where the original manuscript is held. In cases where neither the Archives of American Art nor the Christopher Wilmarth Archive at the Fogg holds the original manuscript (for example, correspondence that Wilmarth photocopied before mailing), the citation is given to the copy in The Christopher Wilmarth Archive at the Fogg Art Museum. In the case of the Archives of American Art, the reel number of the archival material is indicated; for the Fogg material, either the accession number, beginning with the initials CW, or the box number is provided.

1. Christopher Wilmarth, "Addition to the Statement of September 1980," unpublished statement written on November 27, 1980, Christopher Wilmarth Papers, 1956–87, Archives of American Art, Smithsonian Institution, Washington, D.C. (hereafter cited as Wilmarth Papers), reel 4296.

2. Quoted in Maurice Poirier, "Christopher Wilmarth: The Medium is Light," *Art News* 84, no. 10 (December 1985): 70.

3. Christopher Wilmarth, [Statement], in *Christopher Wilmarth: Nine Clearings for a Standing Man*, exh. cat., Wadsworth Atheneum (Hartford, Conn., 1974), n.p.

4. Christopher Wilmarth, [Statement], in *Christopher Wilmarth: Matrix 29*, exh. cat., Wadsworth Atheneum (Hartford, Conn., 1977), n.p.

5. See Lucy Lippard, "Eva Hesse: The Circle," *Art in America* 59, no. 3 (May 1971): 73. Important discussions of sculptors' drawings include Tony Godfrey, *The Body of Drawing: Drawings by Sculptors*, exh. cat., The South Bank Centre (London, 1993); Richard Shone, *From Figure to Object: A Century of Sculptors' Drawings*, exh. cat., Frith Street Gallery and Karsten Schubert Gallery (London, 1996); Terry Friedman, *Four Centuries of Sculptors' Drawings from the Collection of Leeds City Art Galleries*, exh. cat., The Henry Moore Center for the Study of Sculpture (Leeds, 1993); Laura Russell, *Variants: Drawings by Contemporary Sculptors*, exh. cat., Sewall Art Gallery, Rice University (Houston, 1981), and *Diagrams & Drawings*, exh. cat., Kröller Müller Museum (Otterlo, 1972).

6. Quoted in Ernst-Gerhard Güse, ed., *Richard Serra* (New York, 1988), 68.

7. Robert Motherwell, "Thoughts on Drawing," in *The Drawing Society National Exhibition 1970*, exh. cat., American Federation of Arts for the Drawing Society (New York, 1970), n.p.

8. Both "appendix" and "index" are terms used by Richard Serra in describing the role of his own drawings as mostly studies made after completed sculptures. See Güse, *Richard Serra*, 68.

9. Wilmarth chose the title *Christopher Wilmarth: Layers* for a small-scale retrospective, and its accompanying catalogue, at Hirschl and Adler Modern, New York, in 1984.

10. Christopher Wilmarth, "Studio for the First Amendment: Statement–Sept. 1980," unpublished statement, Wilmarth Papers, reel 4296.

11. Quoted in Roland Hagenberg, "The Sun Is Just a Square Upon the Wall," *Artfinder* (spring 1987): 65.

12. "4.25.76" in "Sketchbook," unpublished manuscript, the Christopher Wilmarth Archive, gift of Susan Wilmarth-Rabineau, Fogg Art Museum, Harvard University Art Museums (hereafter cited as Wilmarth Archive), CW2001.786.48 [fol. 48–recto].

13. Wilmarth, "Studio for the First Amendment: Statement," n.p.

14. Christopher Wilmarth, "Dec 15, 1972" in "Sketchbook, Dec 12–31 72," unpublished manuscript, Wilmarth Archive, CW2001.777.3 [fol. 3–recto].

15. Quoted in Dore Ashton, "Christopher Wilmarth: Layers," in *Christopher Wilmarth: Layers, Works from 1961–1984,* exh. cat., Hirschl and Adler Modern (New York, 1984), 5.

16. Christopher Wilmarth, "4.25.76" in "Sketchbook," unpublished manuscript, Wilmarth Archive, CW2001.786.49 [fol. 49–recto].

17. Christopher Wilmarth, statement for exhibition, *Private Images: Photographs by Sculptors,* Los Angeles County Museum of Art, December 20, 1977–March 5, 1978. Wilmarth Papers, reel 4296.

18. See the contact sheet "Sept. 29, 1963, Lower East Side, 'B. B. area,'" in the Wilmarth Photography Album, Wilmarth Archive.

19. *Her Sides of Me* is in the Edward R. Broida collection. Brancusi remained a lifelong source of inspiration for Wilmarth. *Days on Blue* (1977), Wilmarth's largest sculpture, which he described as a "psychological gate" (see Poirier, "Christopher Wilmarth: The Medium is Light," 70), was directly inspired by Brancusi's *Gate of the Kiss,* which Wilmarth had visited in Tirgu-Jiu, Romania, in 1974.

20. Wilmarth rejected and did not preserve much of the work that he made in the 1960s, declaring it to be "negative and graphic, ungenerous and overly self-involved." See Wilmarth, "Studio for the First Amendment: Statement," n.p.

21. Christopher Wilmarth, in a draft of a letter to Hilton Kramer, January 29, 1978, Wilmarth Archive, Box 70. On an annotated draft of Joseph Masheck's essay "Wilmarth's New Reliefs" (later published in *Christopher Wilmarth: Nine Clearings for a Standing Man,* n.p.), Wilmarth deletes large sections of the essay devoted to his relationship with contemporary artists. Writing in the margins of the essay, he edits the text with a series of fascinating comments that throw light on who and what inspired him. On page 7 of the essay, Wilmarth deletes the comparison that Masheck makes between his sculpture and that of Richard Serra. In its place he makes a parallel between the relationship that the *Nine Clearings for a Standing Man* have with the wall they stand up against and Matisse's Back series of monumental sculptures. On page 11, Wilmarth notes: "Where is Matisse? Where are Matisse's beautiful charcoal drawings and their lovely light quality? / Where's Rothko? / Where's Brancusi? <u>Where's Torso of a Young Man</u> / Where's Joseph Paxton? Where's the glass and steel structures of 19 cent. England?" On page 13: "Where's Edward Hopper with *Nighthawks?, Light in an Empty Room?* / Where's Tony Smith?" Wilmarth Papers, reel 4296.

22. Jean Clair, ed., "Correspondance Matisse-Bonnard (1925/46), *La Nouvelle Revue Française 18*, no. 211 (July 1970): 92. As quoted in John Elderfield, *The Cut-Outs of Henri Matisse* (New York: 1978), 20.

23. See Jack Flam, *Matisse on Art* (London and New York: 1973), 90–91.

24. In conversation, Susan Wilmarth-Rabineau and Betty Cuningham both posited a possible alternative reading for these blank ovoid heads. The complete absence of the head or of any facial features, they noted, could be interpreted as an early indication of Wilmarth's desire, expressed in 1984, of "Living inside myself." (Christopher Wilmarth, "Pages, Places and Dreams [or the Search for Jackson Island]," *Poetry East,* nos. 13 and 14 [spring/summer 1984]: 173). In the case of these portrait drawings, one could see him as having become part of Susan, so that he is instead living inside her head, to the point that her external facial features are no longer important to define.

25. Written for the exhibition *Private Images: Photographs by Sculptors,* Los Angeles County Museum of Art, December 20, 1977–March 5, 1978.

26. See *Christopher Wilmarth,* exh. cat., Graham Gallery (New York, 1968).

27. I would like to thank Susan Wilmarth-Rabineau for this information. Wilmarth openly admitted that there was "a funny back-and-forth thing" between the furniture he had been making since 1965 and his sculpture. See Grace Glueck, "Christopher Wilmarth: Graham Gallery," *Art in America 56,* no. 5 (September/October 1968): 112.

28. Wilmarth, "Dec 15, 1972," Wilmarth Archive, CW2001.777.3 [fol. 3–recto].

29. Christopher Wilmarth, "Clarification for the Statement of September

1980," unpublished statement written on November 26, 1980. Wilmarth Papers, reel 4296.

30. Quoted in Corinne Robins, "The Circle in Orbit," *Art in America 56*, no. 6 (1968): 63. It should be noted that Wilmarth stressed throughout his career that he was not a glass artist and that his work should not be explored in material terms. In a letter to Sherry Lang, acting curator of the DeCordova Museum, Lincoln, Mass., dated May 10, 1981 (in the object file for Christopher Wilmarth, *Grey-Blue for Hank Williams, No. 2*, 1973. 104, Department of Modern and Contemporary Art, Fogg Art Museum), Wilmarth notes: "Over the years I have assiduously avoided exhibitions whose focus is glass. I do not wish to have my art explored in material terms. The materials I use are a vehicle for poetic metaphor, the medium is light, and the subject is experience. I feel that museums that mount exhibitions of this nature do a disservice to their public by drawing attention away from the true purpose of art which is spiritual, by elevating 'style,' 'technique,' and 'material' to the level of subject."

31. Poirier, "Christopher Wilmarth: The Medium is Light," 70.

32. Wilmarth, "4.25.76" in "Sketchbook," Wilmarth Archive, CW2001.786.31 [fol. 31–verso].

33. Although it is not clear how Wilmarth arrived at the etching technique, the manner in which the acid is brushed onto the surface of the glass recalls how he painted the surface of his early wood sculptures. As a studio assistant to the sculptor Tony Smith from 1967 until 1969, Wilmarth was also involved in painting Smith's large wooden models. However, intriguingly, Wilmarth also took a number of photographs in November 1963 of Chinatown and the Fulton Street Fish Market in New York, some of which have as their subject large blocks of ice whose surfaces bear striking parallels with the acid's effect on the glass of his sculptures. See the contact sheet "Nov. 1963—Dance at Judson/Chinatown" in the Wilmarth Photography Album, Wilmarth Archive.

34. Quoted in Grace Glueck, "Christopher Wilmarth: Paula Cooper Gallery," *Art in America 59*, no. 2 (March/April 1971): 46. This effect is most apparent when *Shady Gibson* is viewed from the side, or with the related work, *Gibson* (1971; private collection, Switzerland), which is almost identical in all respects except that its glass is not etched, making the piece entirely transparent.

35. Quoted in Arnold Edinborough, "'American Accents': A Tribute to the Passion to Communicate," *Financial Post*, June 25, 1983.

36. Wilmarth took a number of calligraphy courses at Cooper Union. For examples of his calligraphy, see the following handbound calligraphy books: CW2001.809, CW2001.811, and CW2001.811, all in Wilmarth Archive.

37. For example, see CW2001.786 and CW2001.813, Wilmarth Archive.

38. See CW2001.802, CW2001.805, CW2001.806 and CW2001.807, Wilmarth Archive. Of the four sketchbooks, CW2001.806 and CW2001.807 were partially unbound by Wilmarth. The now individual sheets are catalogued under CW2001.803.1–14 (fourteen unbound pages) and CW2001.804.1–13 (thirteen unbound pages). Wilmarth unbound the sketchbooks so that he could photocopy some of the drawings for his proposal for the memorial.

39. Christopher Wilmarth, *Remembrance: A Memorial to those American Merchant Marines who lost their lives in peaceful commerce and in wars against foreign foes, in defense of the freedom this nation now enjoys*. Privately published in a limited edition of twenty signed copies, 1987, p. 3

40. See letter dated September 24, 1979, to Mrs. Phyllis Burson, director of The Office of Community Enrichment, Corpus Christi, Texas. Wilmarth Papers, reel 4295.

41. Wilmarth also made a very small number of perfectly scaled maquettes from glass and steel, usually as a means to show prospective juries or clients the work in question. Among these are maquettes for the sculpture *Calling* (private collection, San Francisco) and *The Gift of the Bridge* (Collection of Susan Wilmarth-Rabineau, New York).

42. Hagenberg, "The Sun Is Just a Square Upon the Wall," 63–64.

43. Ironically, precisely because many artists in the 1960s and 1970s had tried to eliminate any sense of the personal touch in their work, preferring to rely on mass-produced anonymous materials and outside contractors, these personally executed instructional drawings became ever more critical. See Pamela M. Lee, "Some Kinds of Duration: The Temporality of Drawing as Process Art," in Cornelia M. Butler and Pamela M. Lee, *Afterimage: Drawing Through Process*, exh. cat., The Museum of Contemporary Art (Los Angeles, 1999), 25–48. See also Gunnar B. Kvarab and Jon Hendricks, *After the Beginning and Before the End: Instruction Drawings from The Gilbert and Lila Silverman Collection, Detroit*, exh. cat., Bergen Kunstmuseum (Bergen, 2001).

44. For documentation concerning this project see Wilmarth Papers, reel 4295. Included among the papers is a page entitled "Sequence for drawings for *Calling*," on which Wilmarth sketched the four drawings that are to

accompany the maquette, and described a "sketchpage," "watercolors" (*Three Drawings for Calling* [cat. 39]), "graphite" (*Drawing for Calling* [cat. 40]), and a "large watercolor."

45. Wilmarth "Studio for the First Amendment: Statement," n.p.

46. Wilmarth, *Christopher Wilmarth: Nine Clearings for a Standing Man*, n.p.

47. Christopher Wilmarth, [Statement], in ibid.

48. Wilmarth described this cyclical working process as resembling Balzac's creation of the ninety-five novels that make up *La Comédie humaine*. The novels form a self-contained world, sharing, for example, the same genealogy of characters (some two thousand in all) and returning—often novels apart—to events that occurred in previous stories. See Paula Dietz, "Constructing Inner Space," *New York Arts Journal*, no. 9 (April/May 1978): 27.

49. See Bradford Cook, ed. and trans., *Mallarmé: Selected Prose Poems, Essays, and Letters* (Baltimore, 1956), 21.

50. Wilmarth, "Pages, Places and Dreams (or The Search for Jackson Island)," 171–73.

51. *Stéphane Mallarmé: Collected Poems*, trans. Henry Weinfeld (Berkeley, 1996), xiii.

52. Mallarmé to Henri Cazalis, October 1864, in Cook, ed., *Mallarmé*, 83.

53. Christopher Lyon, "Another Place for Dreams," *The Members Quarterly of The Museum of Modern Art* 2, no. 1 (summer 1989): 23.

54. Grace Glueck, "Mallarmé Poems Inspire Glass Sculpture," *New York Times*, May 14, 1982.

55. Lyon, "Another Place for Dreams," 23.

56. Wilmarth had already used the ovoid shape in one of his earliest works, *Hague Street Memory (for the Old Man Who Spoke with Me)* of 1962 (Susan Wilmarth-Rabineau, New York), and in the portraits of Susan, as mentioned above.

57. Stéphane Mallarmé, trans. Frederick Morgan, in *Christopher Wilmarth: Breath*, exh. cat., The Studio for the First Amendment (New York, 1982), 38.

58. As quoted in Dore Ashton, "Mallarmé, Friend of Artists," in *Christopher Wilmarth: Breath*, 21. This essay remains the most important discussion of Wilmarth's Mallarmé-inspired work.

59. Mallarmé in *Christopher Wilmarth: Breath*, 38.

60. Ibid., 34.

61. For details of Wilmarth's continued interest in glassblowing throughout the 1980s see Brett Littman, "Christopher Wilmarth's Glass Poems," *Glass: The UrbanGlass Art Quarterly*, no. 71 (summer 1998): 47.

62. Wilmarth, *Christopher Wilmarth: Nine Clearings for a Standing Man*, n.p.

63. As annotated by Wilmarth on the first page of a draft of Matti Megged's article "Void, Memory, Place (On the sculptures of Chris Wilmarth, 1983–1986), Wilmarth Papers, reel 4296"; later published as "The Void and the Dream: New Sculptures by Christopher Wilmarth," *Arts Magazine* 61, no. 10 (June/summer 1987): 74–75.

64. The exhibition was held at The Studio for the First Amendment, New York, May 1–29, 1982, with a tour to the Institute of Contemporary Art, Boston, the University Art Museum, Berkeley, and the University Art Museum, Santa Barbara.

65. Wilmarth, writing about himself using the pseudonym Celadón, "Interview #1, Susan Wilmarth, Artist, Brooklyn, New York, June 20, 1986," from "Seven Interviews by Celadón." In *Chris Wilmarth: Delancey Backs (and Other Moments)*, 6–33, exh. cat., Hirschl and Adler Modern (New York, 1986), 9.

66. See *Chris Wilmarth: Delancey Backs (and Other Moments)*.

67. Laura Rosenstock in "Christopher Wilmarth: An Introduction," *Christopher Wilmarth*, exh. cat., Museum of Modern Art (New York, 1989), 17, notes how this imagery of the two heads placed side-by-side separated by an architectural element refers to a photograph Wilmarth owned—a detail of a portal of Chartres Cathedral in which the figures of God and Adam are depicted, heads almost together, confined within a very tight framework.

68. For a fascinating discussion on drawing as "self-projection," see David Rosand, *Drawing Acts: Studies in Graphic Expression and Representation* (Cambridge, 2002): 61–111, especially 105.

69. See "Seven Interviews by Celadón," in *Chris Wilmarth: Delancey Backs (and Other Moments)*, 6–33.

70. Wilmarth, "Clarification for the Statement of September 1980," n.p.

Plates

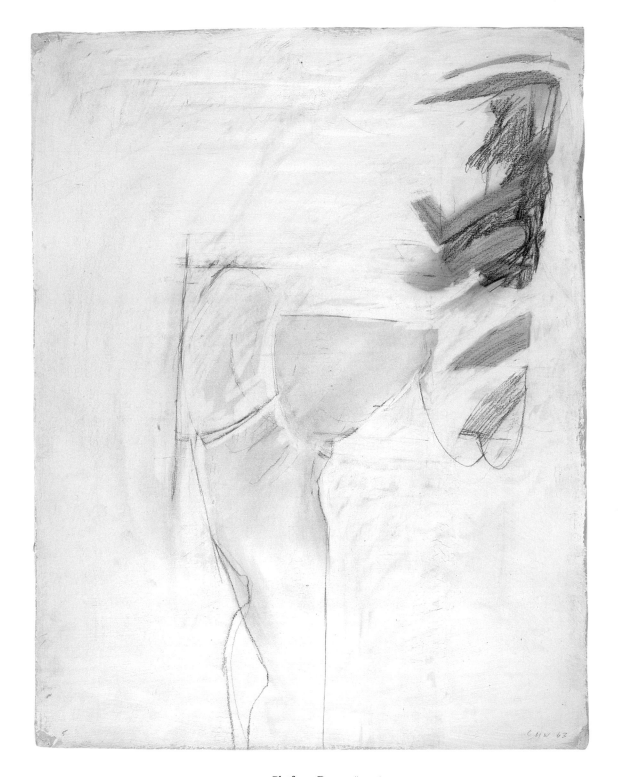

1 Platform Dream #5, 1963

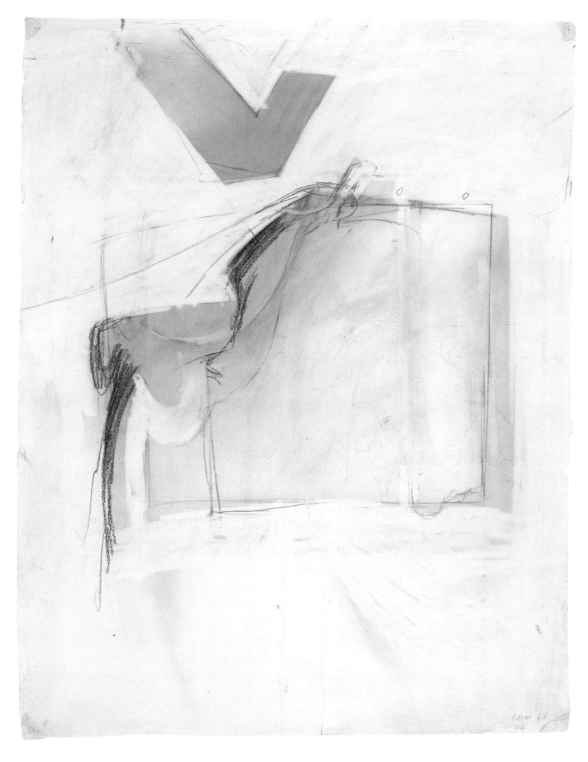

2　Platform Dream #11, 1963

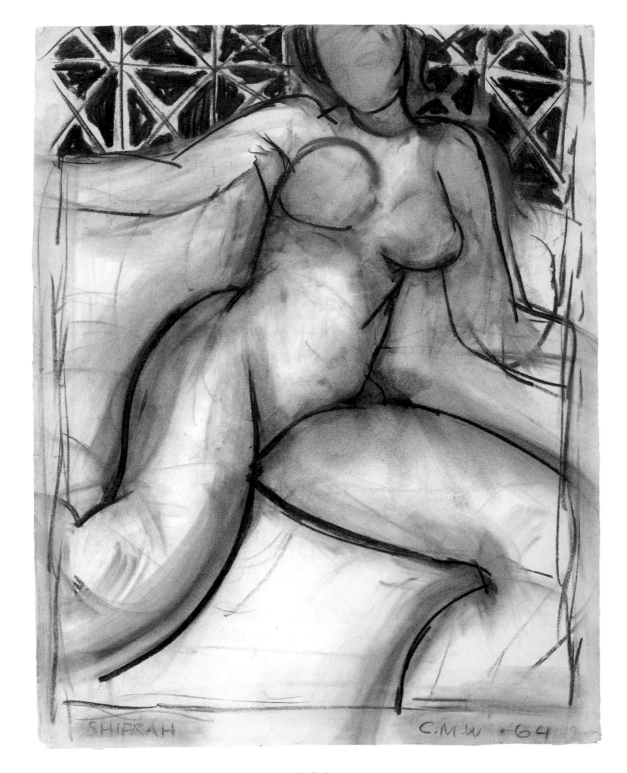

3 Shifrah, 1964

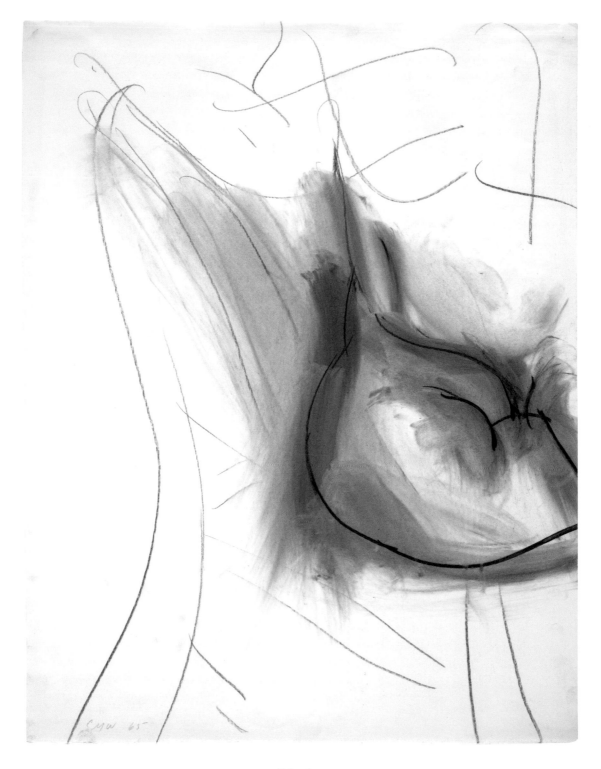

4 Yolande, 1965

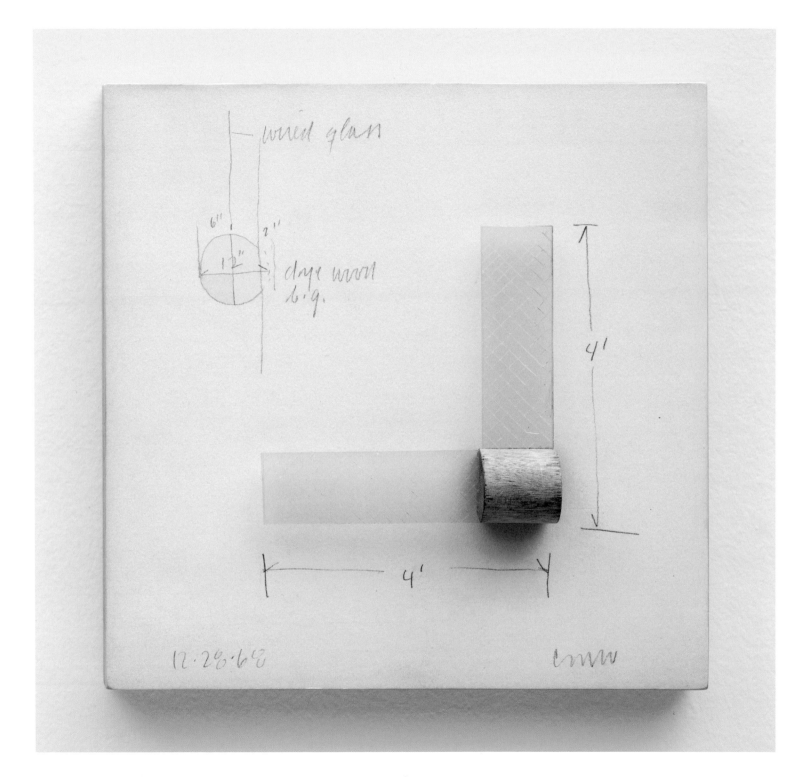

5 Left, 1968

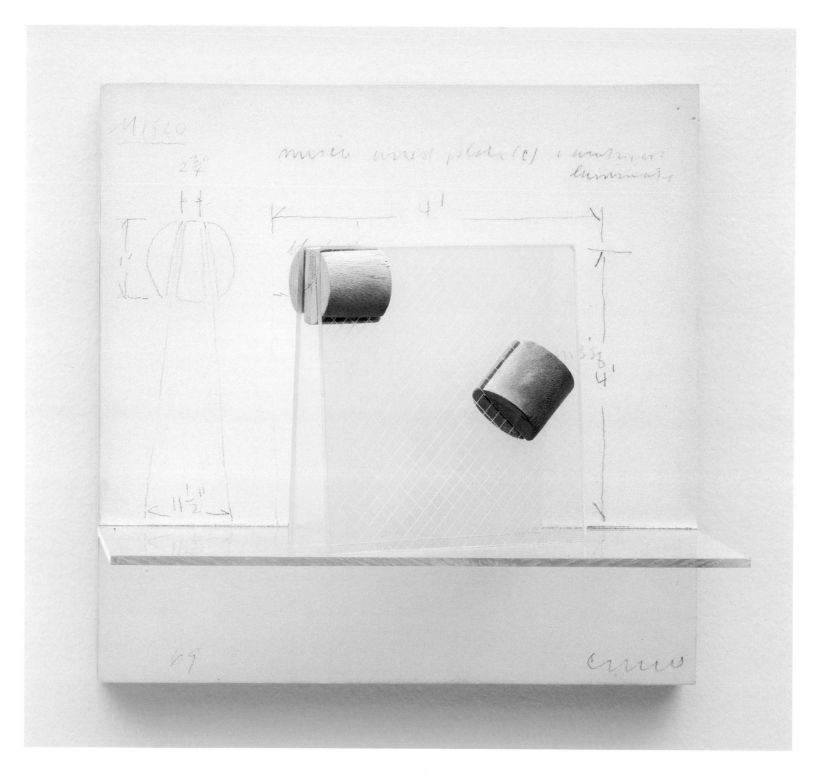

6 Her Sides of Me, 1969

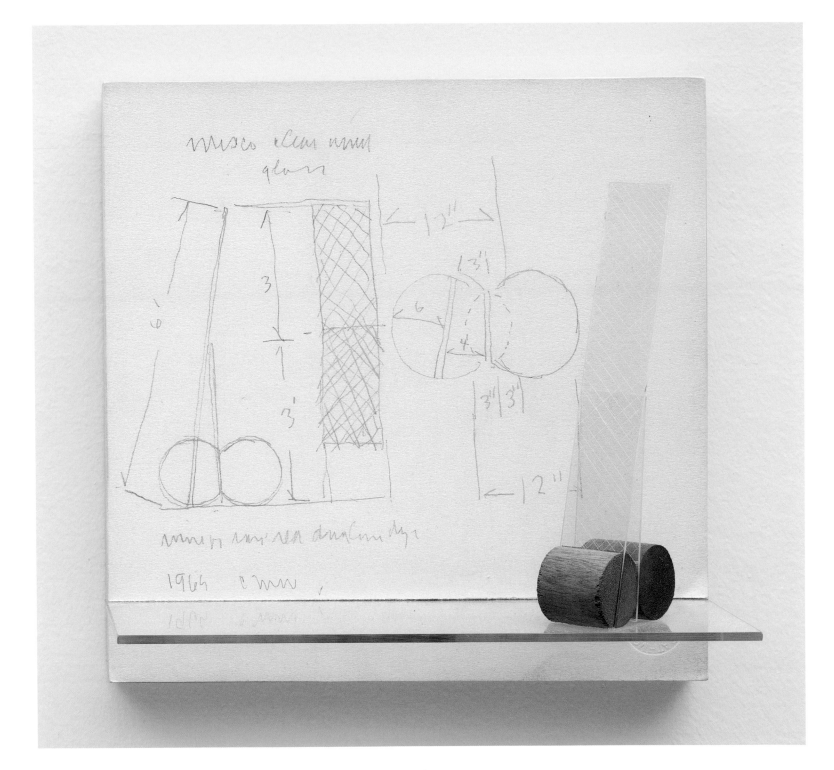

7 Reach, 1969

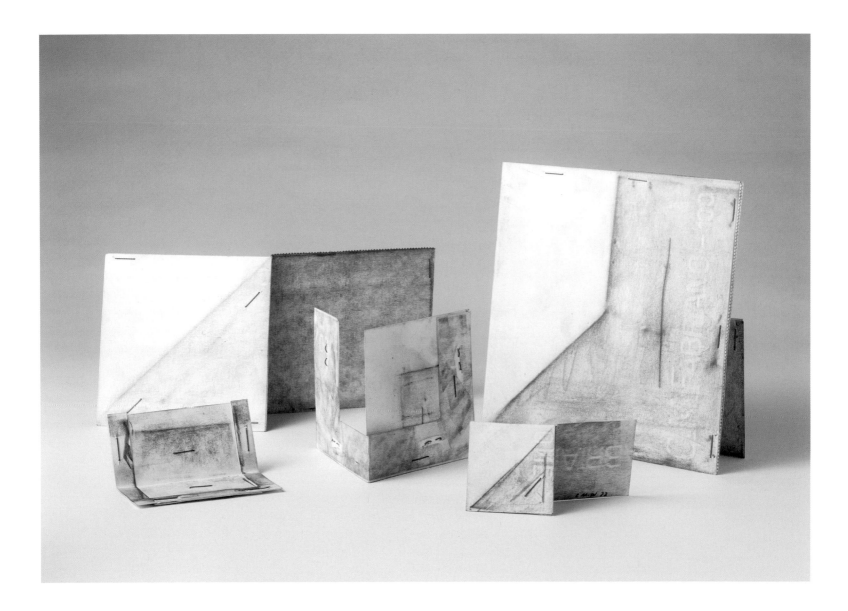

8 Maquette for "Orange Delta for A.P.S.," 1973

9 Maquette for "Orange Delta for A.P.S.," 1973

10 Maquette for "Passing Blue," 1973

11 Maquette for "Alba Sweeps," 1973

12 Maquette for "New Normal Corner," 1973

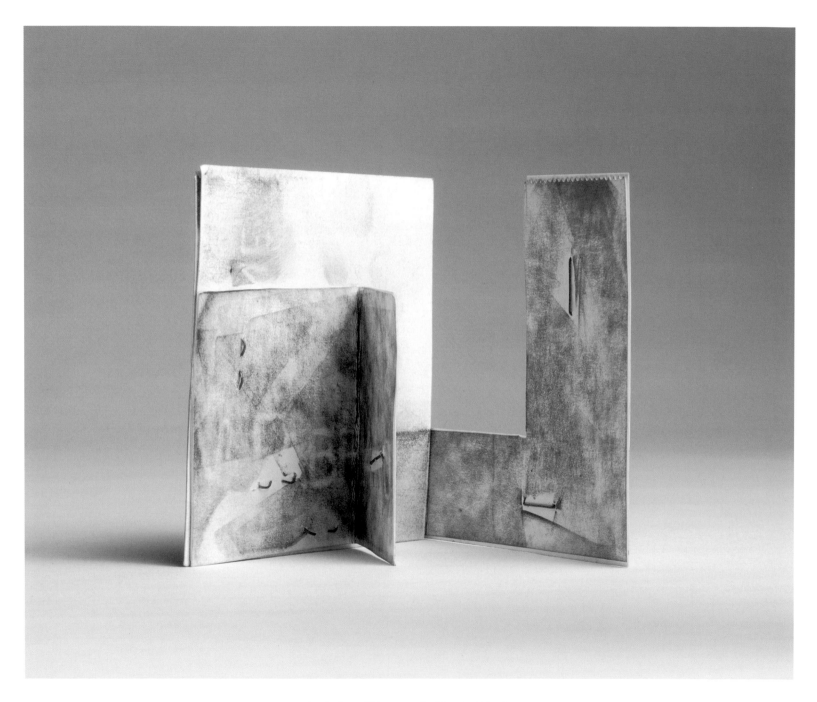

10 Back view of Maquette for "Passing Blue," 1973

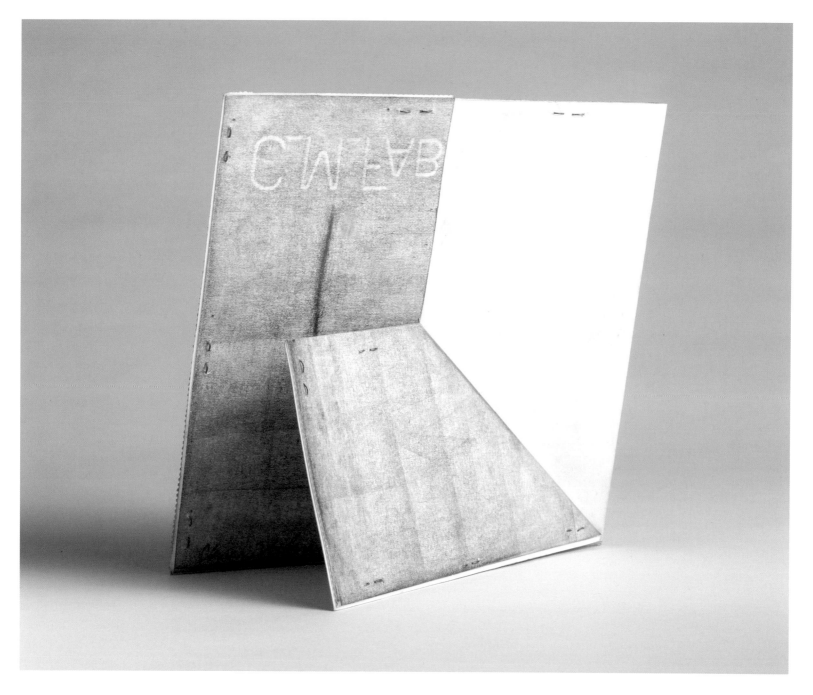

11 Back view of Maquette for "Alba Sweeps," 1973

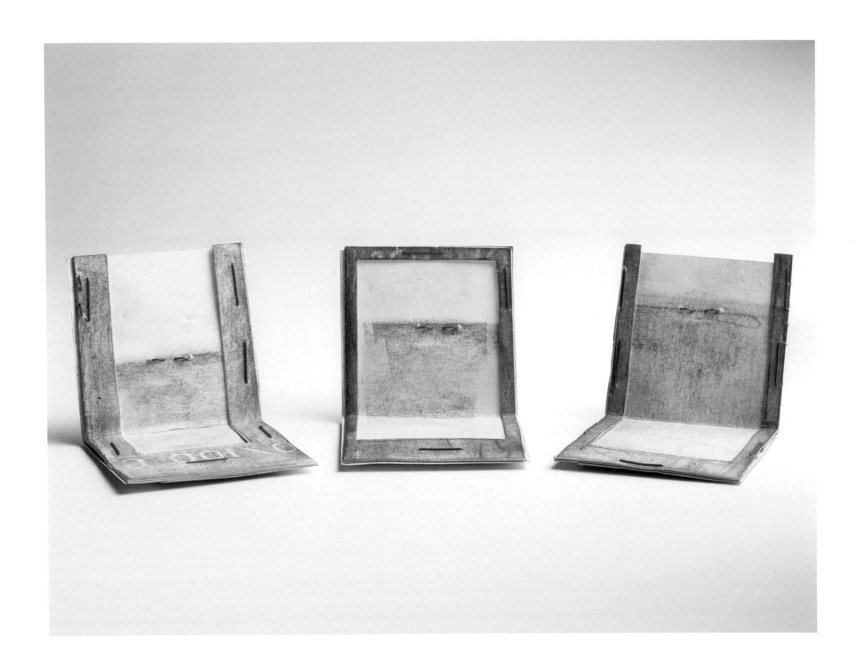

LEFT TO RIGHT: 13, 14, 15 Maquettes for "New Normal Corner," 1973

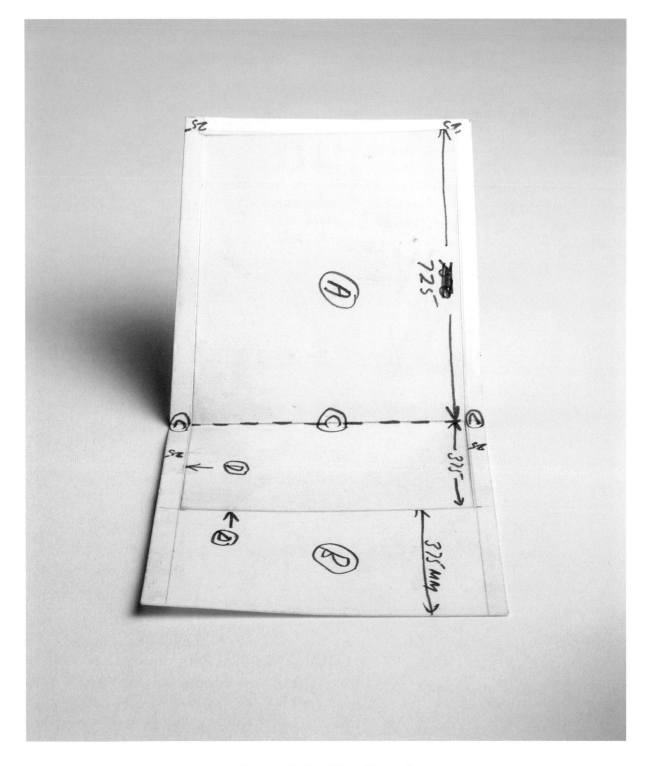

16 Maquette for "New Normal Corner," 1973

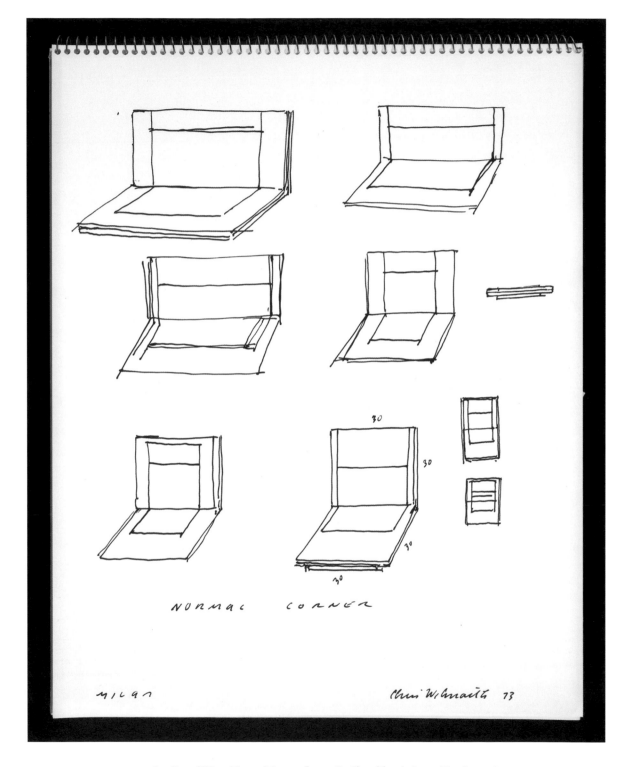

17　Studies of "New Normal Corner," 1973 (In Sketchbook, Jan 1–March 3, 73)

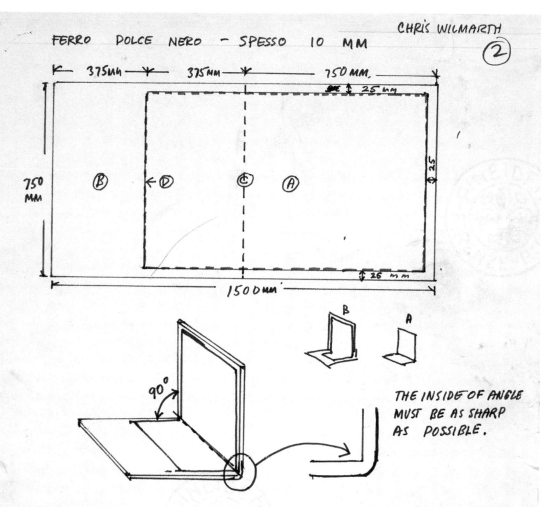

FERRO DOLCE NERO — SPESSO 10 MM CHRIS WILMARTH ②

THE INSIDE OF ANGLE MUST BE AS SHARP AS POSSIBLE.

FIRST BEND ENTIRE PLATE TO A 90° ANGLE AT LINE ©. THEN CUT OUT PIECE Ⓐ AND Ⓑ AT LINE Ⓓ WITH TORCH. HEAT WILL CAUSE DISTORTION SO BOTH PIECES MUST BE SRAIGHTENED AFTER CUTTING. USE A CLEAN PIECE OF STEEL — NO RUST. BOTH PIECES WILL BE USED SO DRILL A SMALL HOLE IN CORNERS OF CUTS. PER GALLERIA ARIETE ②

18 Specification Sheet for "New Normal Corner," 1973

19 Specification sheet for
"Maquette for 'Calling'":
Plate Layout, 1974

20 Specification sheet for
"Maquette for 'Calling'":
Top View after Bending, 1974

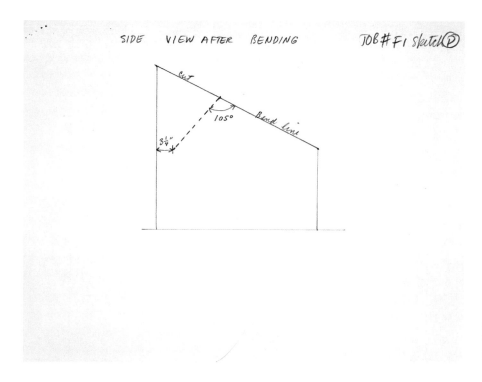

21 Specification sheet for "Maquette for 'Calling'": Side View after Bending, 1974

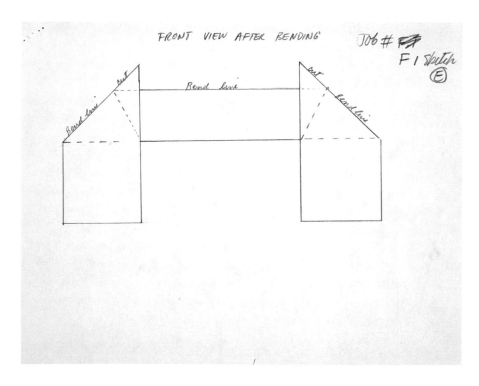

22 Specification sheet for "Maquette for 'Calling'": Front View after Bending, 1974

23 "Line Experimentation Nov–1961," 1961

24 Front Cover of "The Hunger Artist," 1963

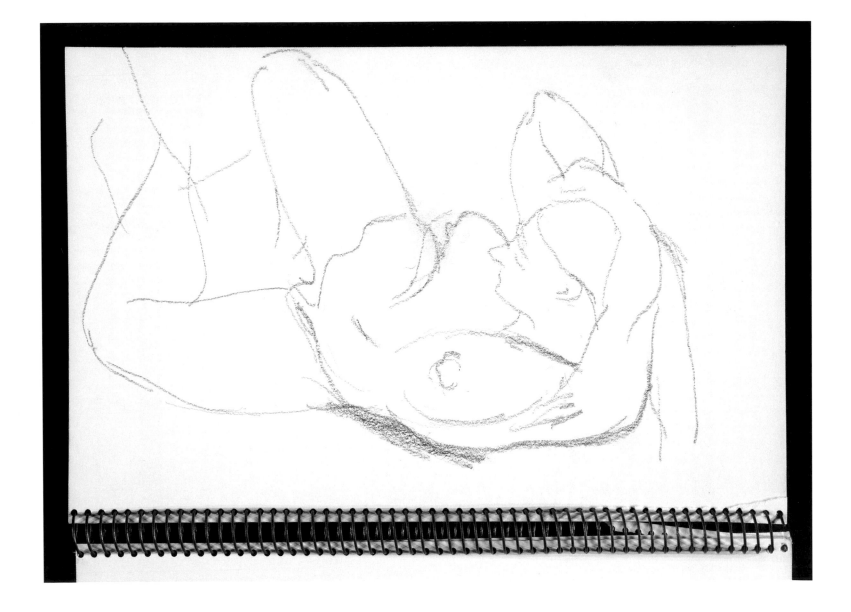

25 Reclining Figure, n.d.

26 Study of "Wyoming," 1975

54

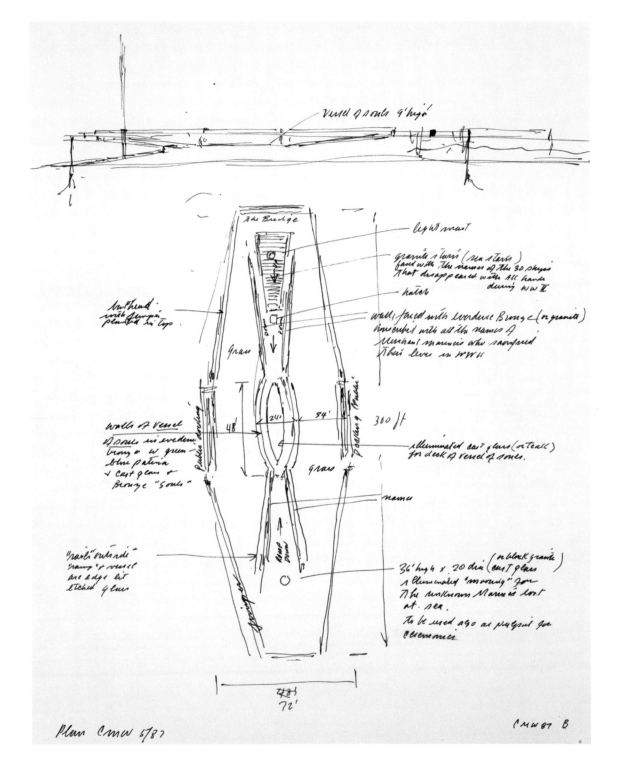

27 Design for the American Merchant Marine Memorial: Plan, 1987

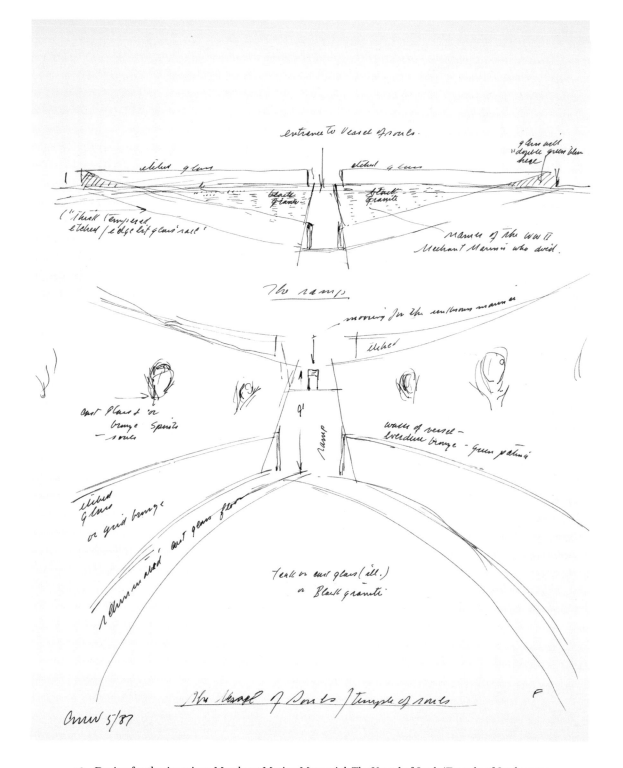

28 Design for the American Merchant Marine Memorial: The Vessel of Souls/Temple of Souls, 1987

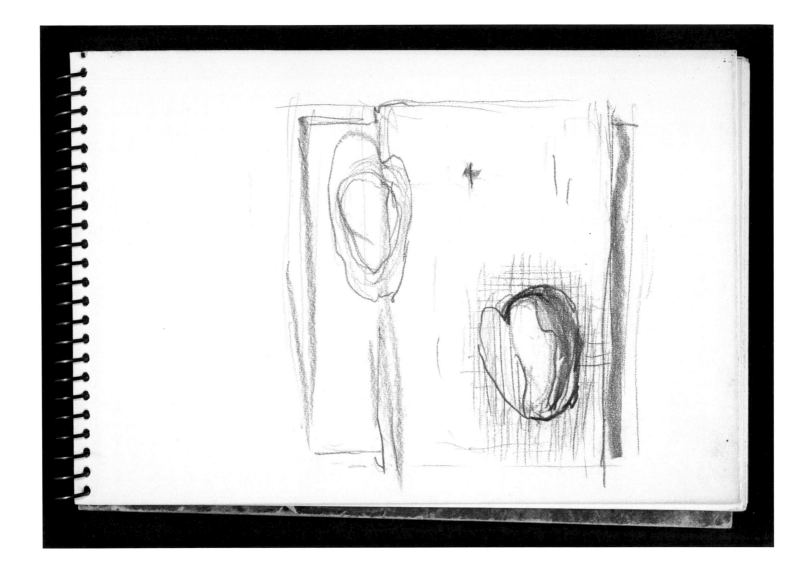

29 Study of Sculpture, c. 1987

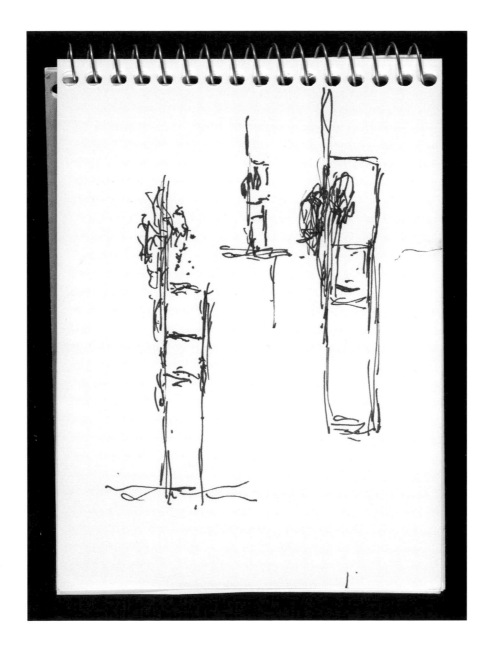

30 Study of Sculpture, 1987

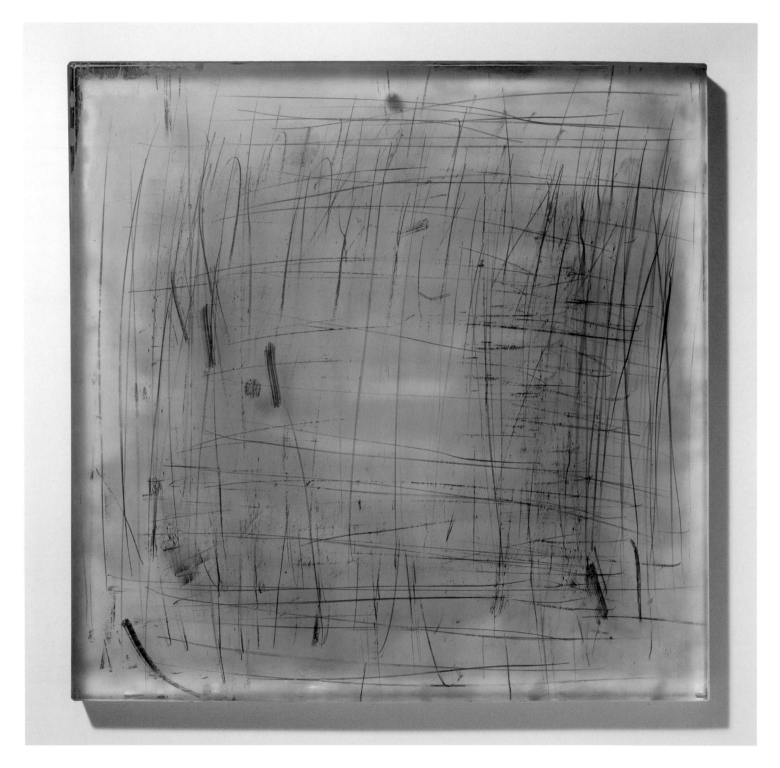

31 Drawing, 1970

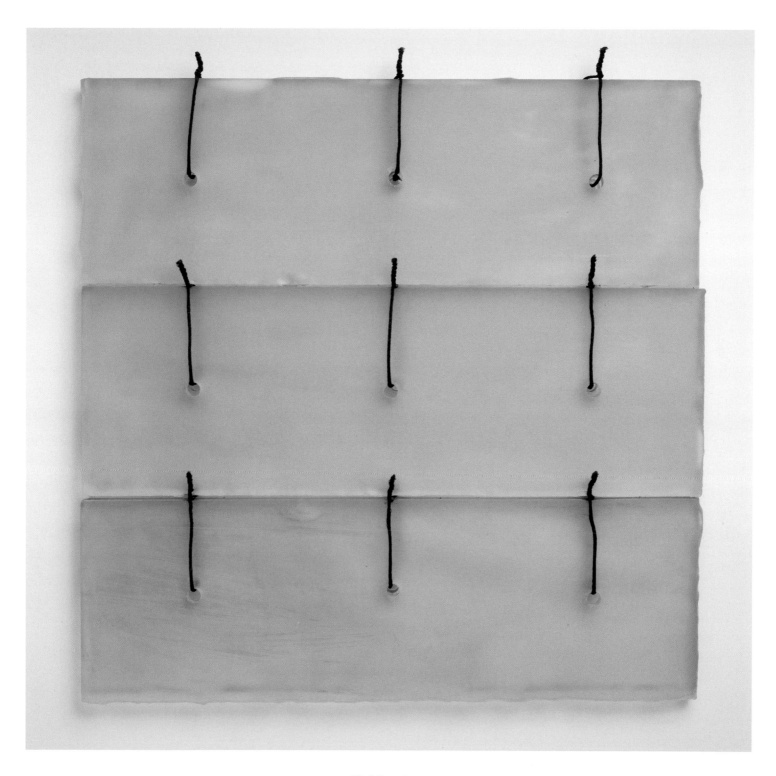

32 Tied Drawing, 1971

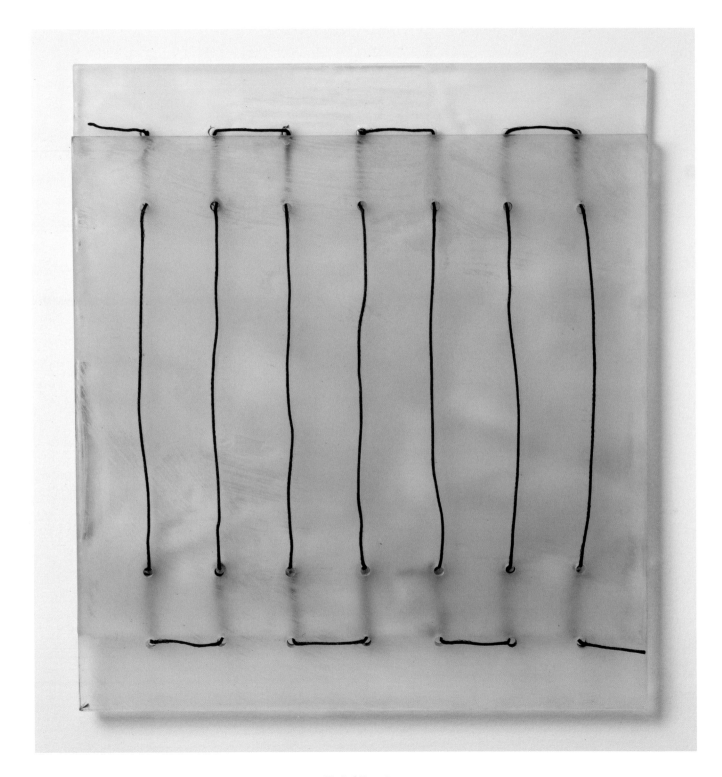

33 Untied Drawing, 1971

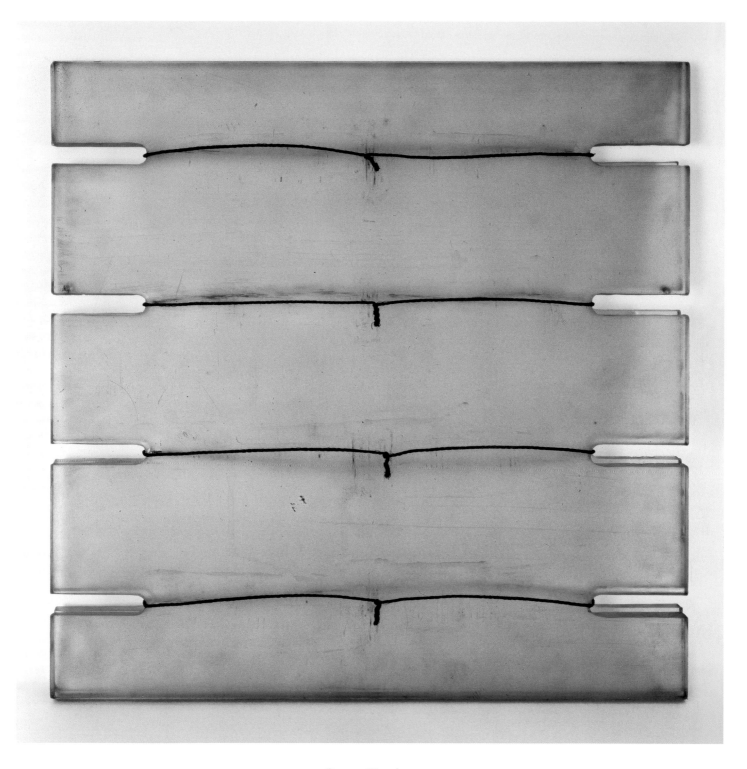

34 Crosscut Drawing, 1972

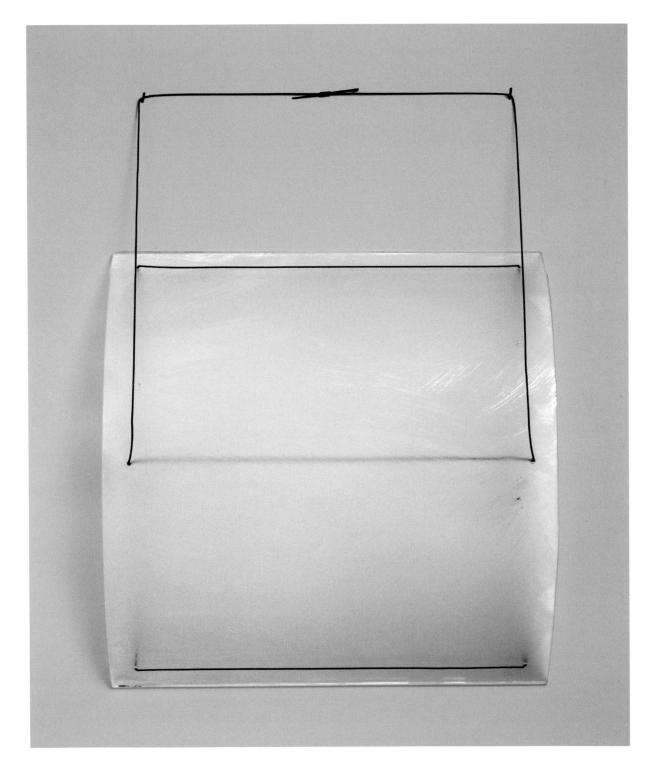

35 Shady Gibson, 1971

36 Stream, 1973

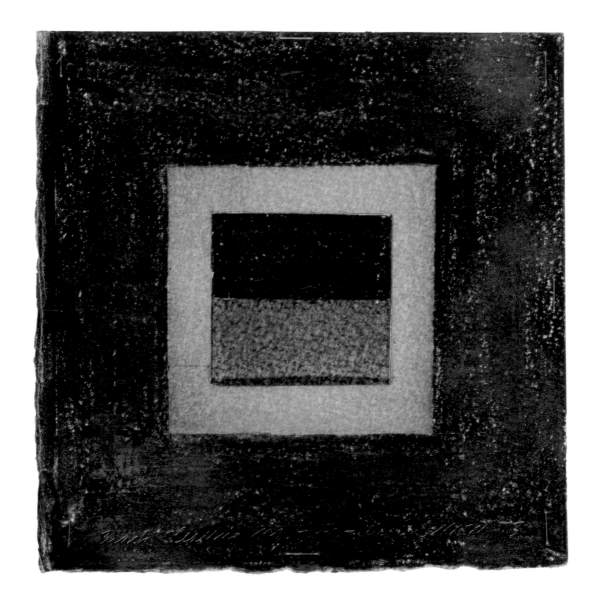

37 Black Clearing #4 for Hank Williams, 1973

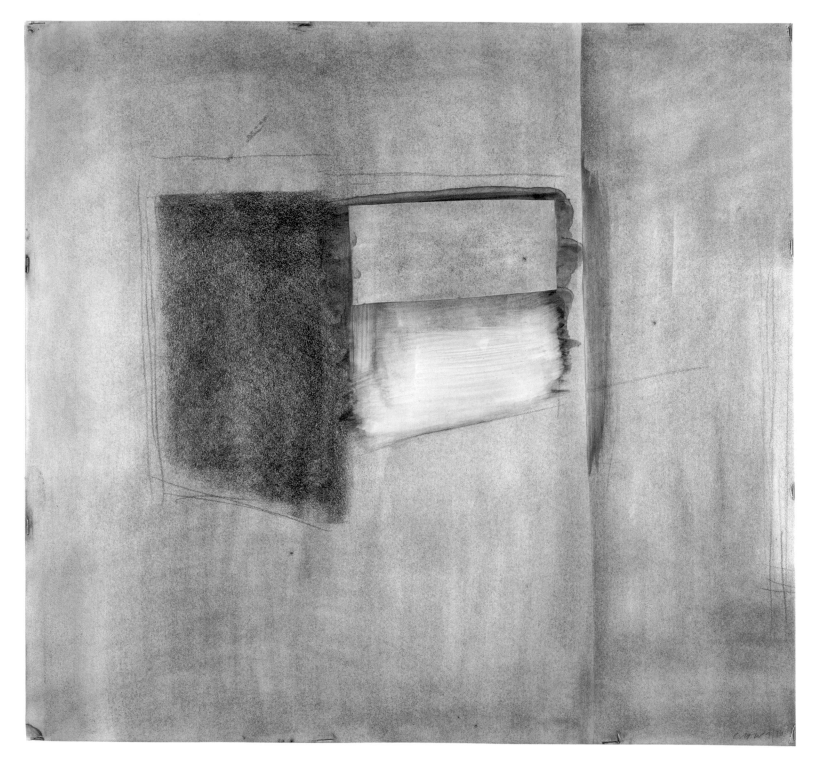

38 Invitation #1, 1976

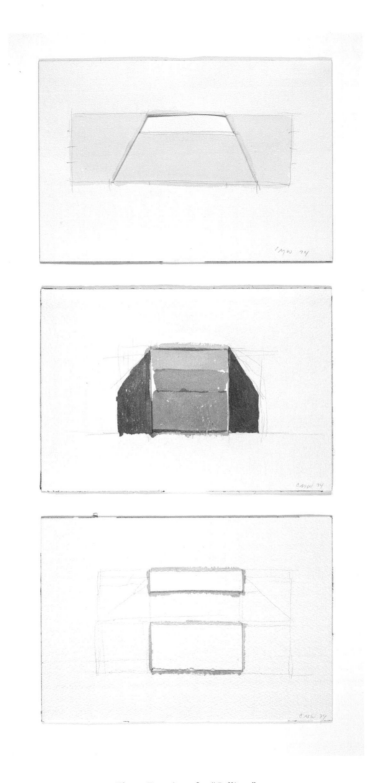

39 Three Drawings for "Calling," 1974

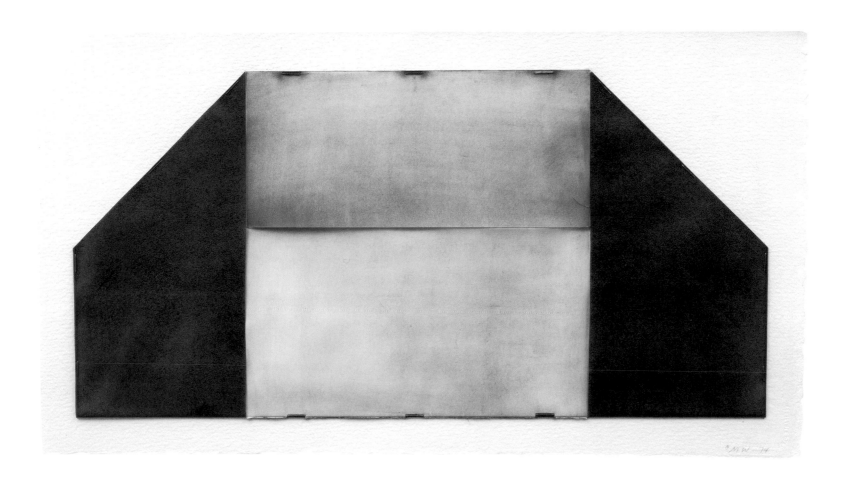

40 Drawing for "Calling," 1974

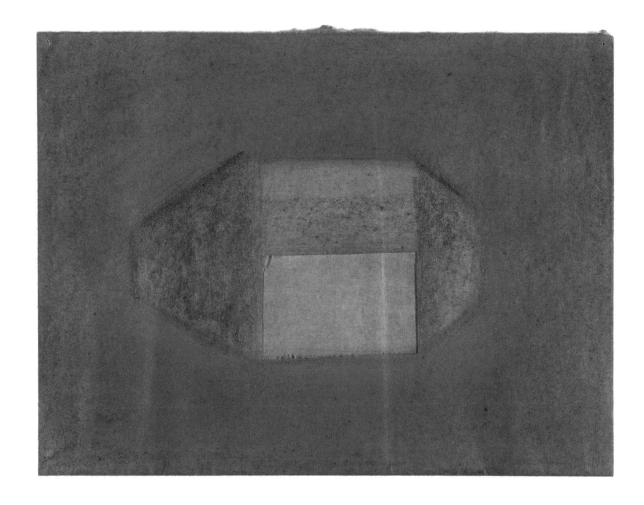

41 Calling, 1976

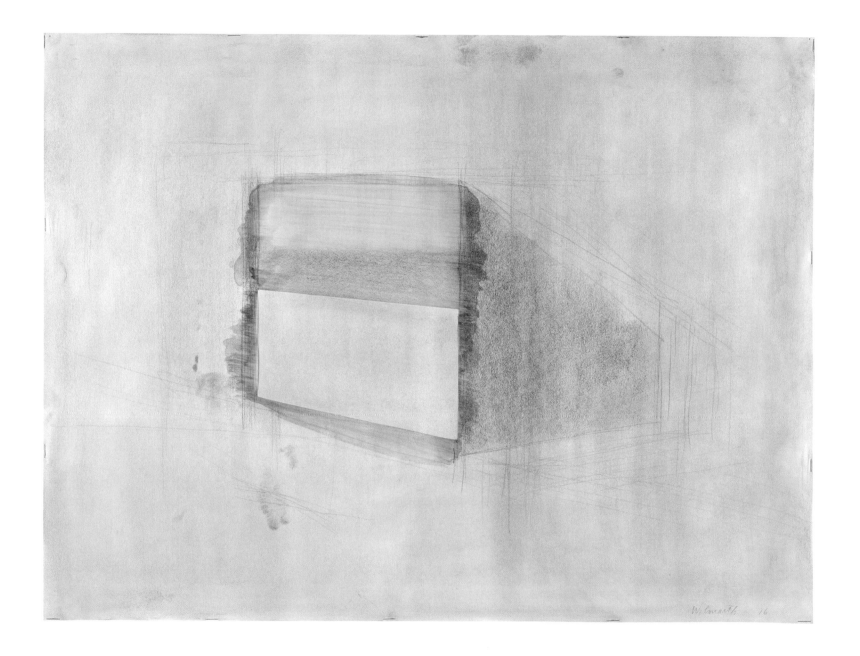

42 Calling, 1976

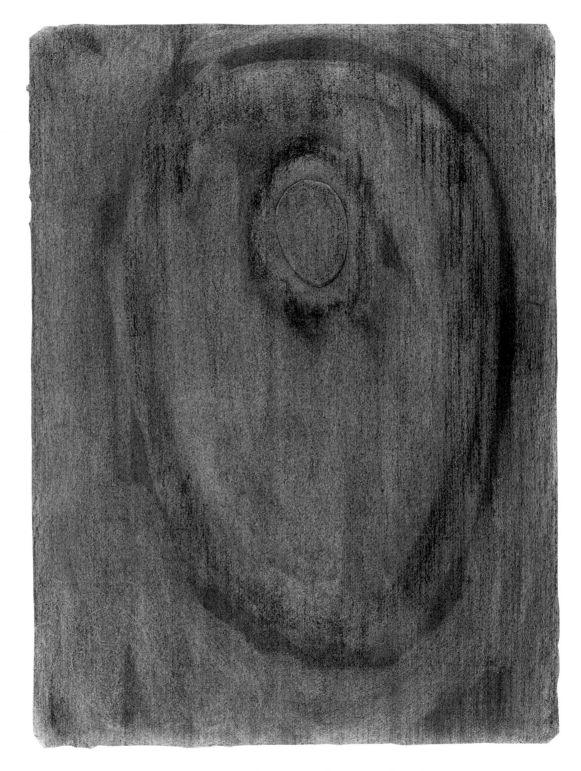

43 "When Winter on forgotten woods moves somber ...," 1979

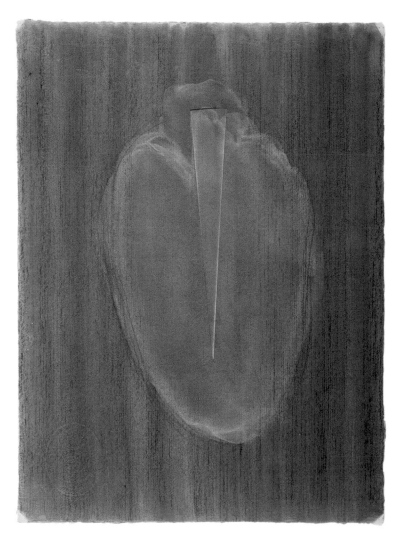

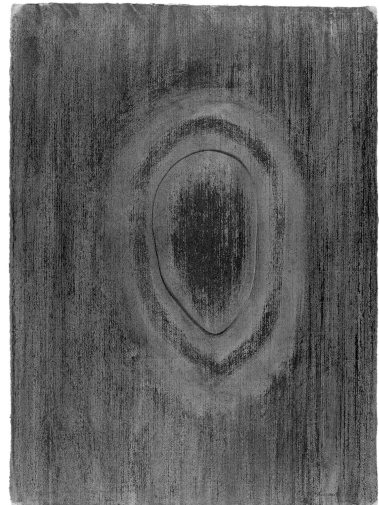

44 Saint, 1979

45 "The whole soul summed up …," 1979

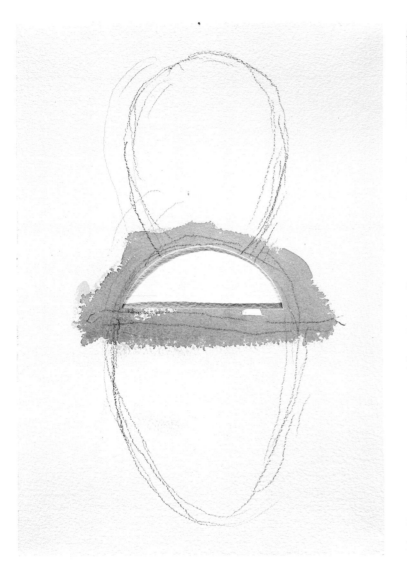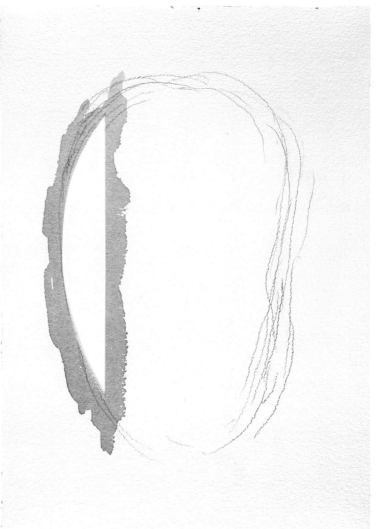

Breath

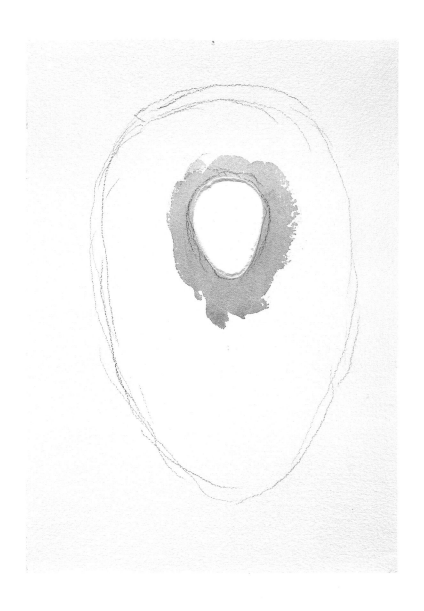

BREATH

From left to right:

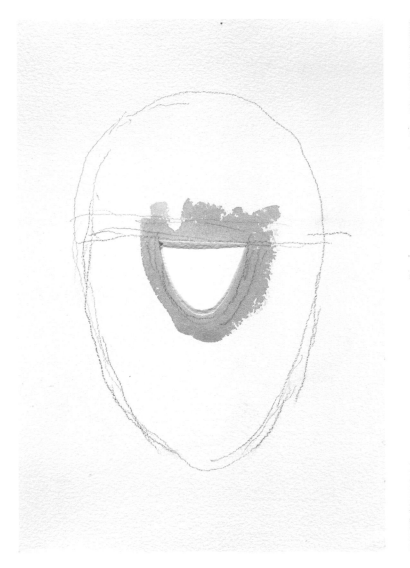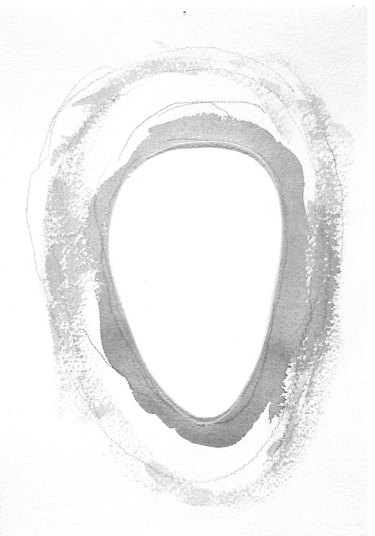

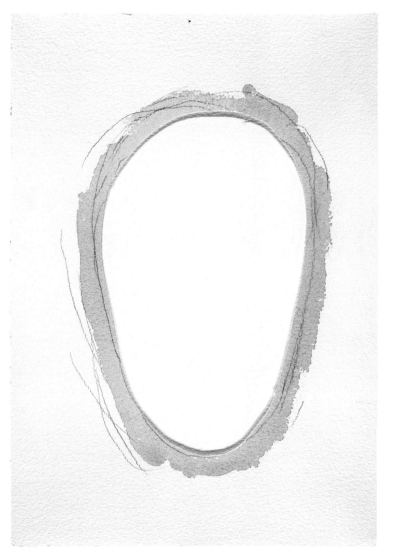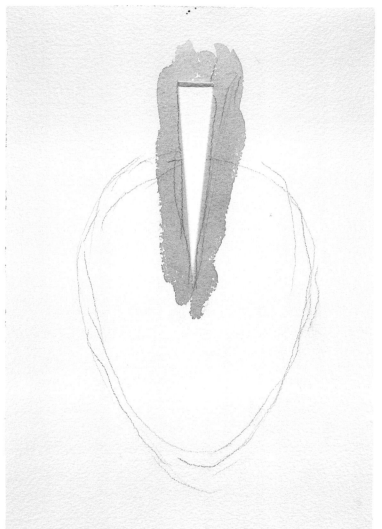

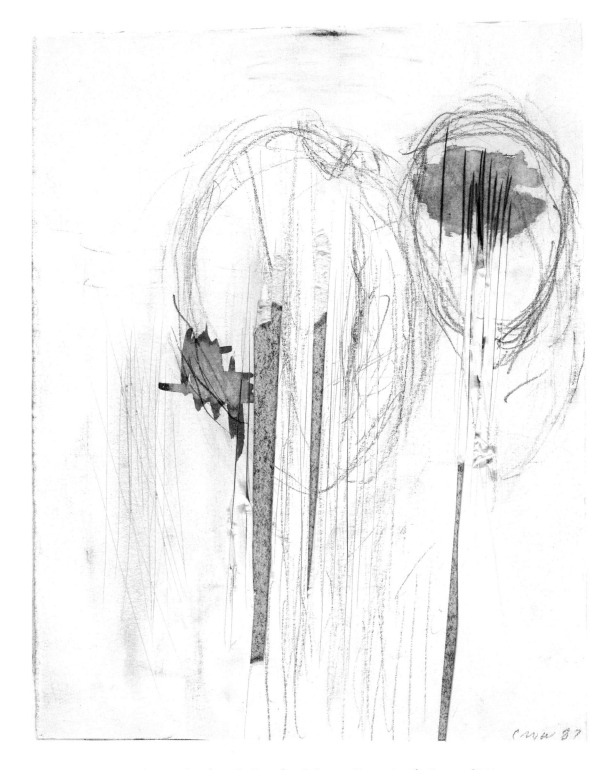

53 Twelve Drawings from the Forty-fourth Year, #2: Emanation (for Enzo and Me), 1987

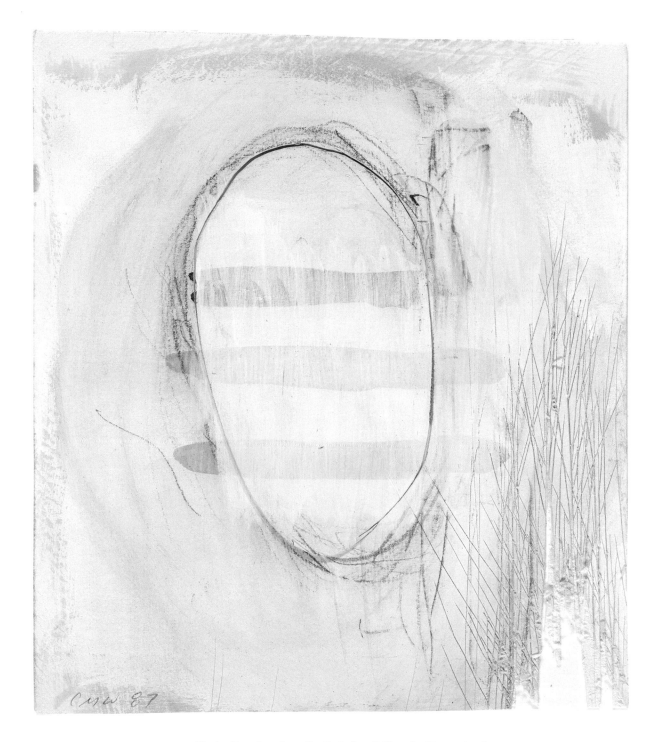

54 Twelve Drawings from the Forty-fourth Year, #9: Moment, 1987

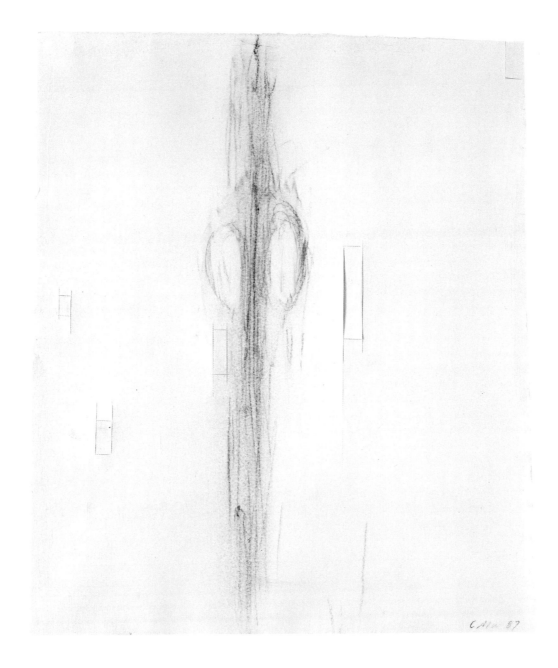

55 Twelve Drawings from the Forty-fourth Year, #12: Delancey Backs, 1987

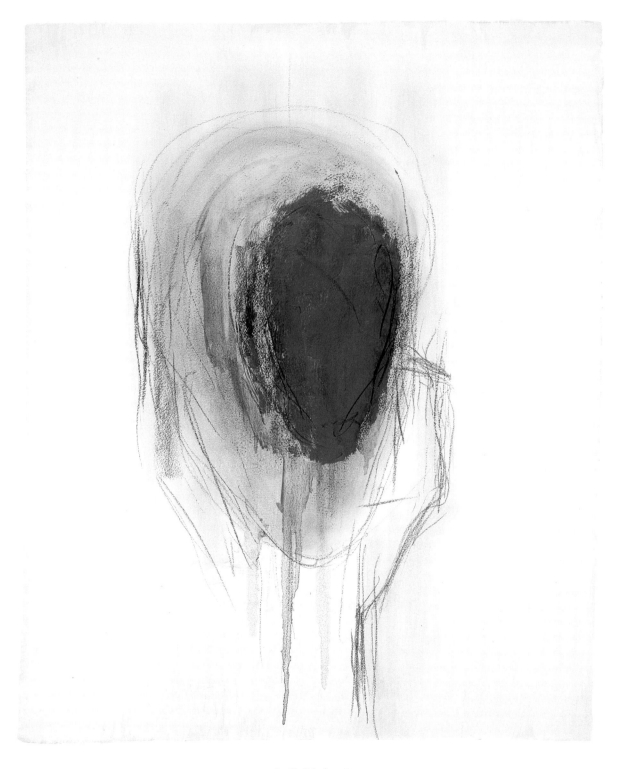

56 Untitled, 1987

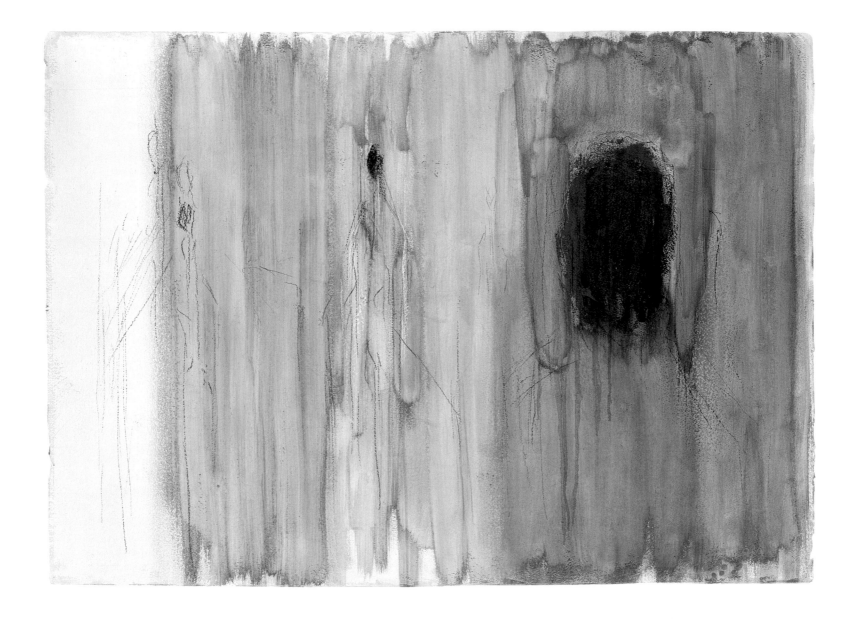

57 Untitled, 1987

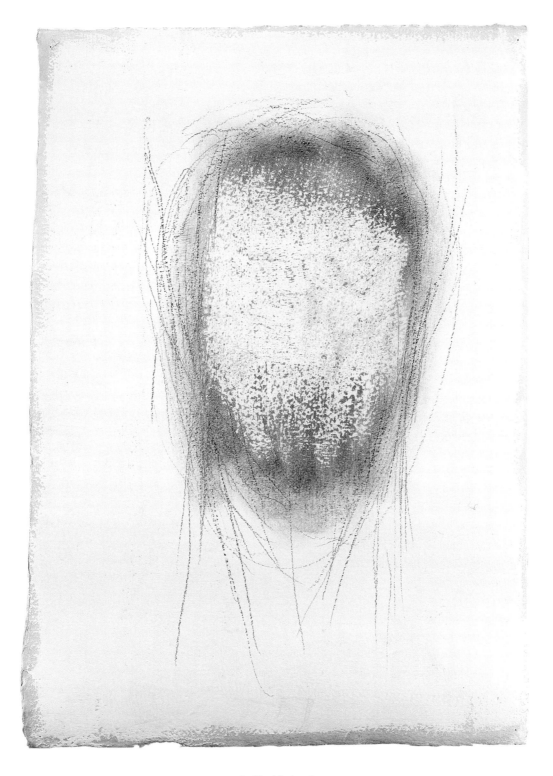

58 Untitled, 1987

CHECKLIST OF THE EXHIBITION

Dimensions are given in centimeters, height preceding width and followed by depth in the case of the works on glass and the three-dimensional maquettes. For sketchbook pages, the dimensions, title, and accession number are provided of the actual exhibited and reproduced page. With the exception of the unbound sketchbooks, the folio number of the sketchbook page is also given. All works are in the collection of the Fogg Art Museum (including those in the Christopher Wilmarth Archive), unless otherwise noted.

1

PLATFORM DREAM #5, 1963
Graphite on gesso-prepared cream wove paper
66.1 x 51.4 cm
Loan from Susan Wilmarth-Rabineau, Courtesy of Robert Miller Gallery, New York
19.2001

2

PLATFORM DREAM #11, 1963
Graphite on gesso-prepared cream wove paper
66.7 x 50.7 cm
Loan from Susan Wilmarth-Rabineau, Courtesy of Robert Miller Gallery, New York
20.2001

3

SHIFRAH, 1964
Charcoal on cream wove paper
66.2 x 51.7 cm
Loan from Susan Wilmarth-Rabineau, Courtesy of Robert Miller Gallery, New York
TL38527

4

YOLANDE, 1965
Charcoal on cream wove paper
61.9 x 47.3 cm
Loan from Susan Wilmarth-Rabineau, Courtesy of Robert Miller Gallery, New York, planned purchase from the Fogg Art Museum's Margaret Fisher Fund, July 2003
32.2001

5

LEFT, 1968
Wood, plastic, and graphite on off-white wove paper mounted on plywood
21.3 x 21.3 x 3.8 cm
The Museum of Modern Art, New York, Gift of Agnes Gund
TL38325.1

6

HER SIDES OF ME, 1969
Wood, plastic, and graphite on off-white wove paper mounted on plywood
21.3 x 21.3 x 3.8 cm
The Museum of Modern Art, New York, Gift of Agnes Gund
TL38325.2

7

REACH, 1969
Wood, plastic, and graphite on off-white wove paper mounted on plywood
21.3 x 21.3 x 3.8 cm
The Museum of Modern Art, New York, Gift of Agnes Gund
TL38325.3

8

MAQUETTE FOR "ORANGE DELTA FOR A.P.S.,"
1973
Graphite and staples on cream card
4.6 x 9.2 x 1.9 cm
The Christopher Wilmarth Archive, gift of Susan
Wilmarth-Rabineau
CW2001.829

9

MAQUETTE FOR "ORANGE DELTA FOR A.P.S.,"
1973
Graphite and staples on cream card
10.5 x 21 x 4.2 cm
The Christopher Wilmarth Archive, gift of Susan
Wilmarth-Rabineau
CW2001.845

10

MAQUETTE FOR "PASSING BLUE," 1973
Graphite and staples on cream card
8.2 x 8.4 x 8.1 cm
The Christopher Wilmarth Archive, gift of Susan
Wilmarth-Rabineau
CW2001.836

11

MAQUETTE FOR "ALBA SWEEPS," 1973
Graphite and staples on cream card
16.1 x 16.1 x 7 cm
The Christopher Wilmarth Archive, gift of Susan
Wilmarth-Rabineau
CW2001.876

12

MAQUETTE FOR "NEW NORMAL CORNER," 1973
Graphite and staples on cream card

4 x 8 x 4 cm
The Christopher Wilmarth Archive, gift of Susan
Wilmarth-Rabineau
CW2001.837

13

MAQUETTE FOR "NEW NORMAL CORNER," 1973
Graphite and staples on cream card
5.3 x 5.4 x 5.3 cm
The Christopher Wilmarth Archive, gift of Susan
Wilmarth-Rabineau
CW2001.828

14

MAQUETTE FOR "NEW NORMAL CORNER," 1973
Graphite and staples on cream card
5 x 5.2 x 5 cm
The Christopher Wilmarth Archive, gift of Susan
Wilmarth-Rabineau
CW2001.826

15

MAQUETTE FOR "NEW NORMAL CORNER," 1973
Graphite and staples on cream card
5 x 5.2 x 5 cm
The Christopher Wilmarth Archive, gift of Susan
Wilmarth-Rabineau
CW2001.827

16

MAQUETTE FOR "NEW NORMAL CORNER," 1973
Black ink and graphite on two pieces of white
wove paper
7.4 x 7.6 x 7.6 cm
The Christopher Wilmarth Archive, gift of Susan
Wilmarth-Rabineau
CW2001.871

17

STUDIES OF "NEW NORMAL CORNER," 1973
(In SKETCHBOOK, JAN 1–MARCH 3, 73)
Black ink on white wove paper
35.4 x 28 cm
The Christopher Wilmarth Archive, gift of Susan
Wilmarth-Rabineau
CW2001.778.10 (fol. 10–recto)

18

SPECIFICATION SHEET FOR "NEW NORMAL
CORNER," 1973
Black ink on white wove paper
28 x 22 cm
The Christopher Wilmarth Archive, gift of Susan
Wilmarth-Rabineau
CW2001.1045

19

SPECIFICATION SHEET FOR "MAQUETTE FOR
'CALLING'": PLATE LAYOUT, 1974
Graphite on cream wove paper
21.6 x 28 cm
The Christopher Wilmarth Archive, gift of Susan
Wilmarth-Rabineau
CW2001.1203

20

SPECIFICATION SHEET FOR "MAQUETTE FOR
'CALLING'": TOP VIEW AFTER BENDING, 1974
Graphite on cream wove paper
21.6 x 28 cm
The Christopher Wilmarth Archive, gift of Susan
Wilmarth-Rabineau
CW2001.1204

21
SPECIFICATION SHEET FOR "MAQUETTE FOR
'CALLING'": SIDE VIEW AFTER BENDING, 1974
Graphite on cream wove paper
21.6 x 28 cm
The Christopher Wilmarth Archive, gift of Susan
Wilmarth-Rabineau
CW2001.1206

22
SPECIFICATION SHEET FOR "MAQUETTE FOR
'CALLING'": FRONT VIEW AFTER BENDING, 1974
Graphite on cream wove paper
21.6 x 28 cm
The Christopher Wilmarth Archive, gift of Susan
Wilmarth-Rabineau
CW2001.1207

SKETCHBOOKS

(catalogue numbers 23 to 30)

23
"LINE EXPERIMENTATION NOV–1961," 1961
Collage and graphite on cream wove paper
30.3 x 22.5 cm
The Christopher Wilmarth Archive, gift of Susan
Wilmarth-Rabineau
CW2001.775.24 (fol. 24-recto)

24
"THE HUNGER ARTIST," 1963
Watercolor and graphite on handbound cover
32.5 x 25.5 cm
The Christopher Wilmarth Archive, gift of Susan
Wilmarth-Rabineau
CW2001.810 (front cover)

25
RECLINING FIGURE, n.d.
Graphite on cream wove paper
17.8 x 27 cm
The Christopher Wilmarth Archive, gift of Susan
Wilmarth-Rabineau
CW2001.792.5 (fol. 5-recto)

26
STUDY OF "WYOMING," 1975
Watercolor, gouache, and graphite on cream
wove paper
20.9 x 12.5 cm
The Christopher Wilmarth Archive, gift of Susan
Wilmarth-Rabineau
CW2001.791.11 (fol. 11-recto)

27
DESIGN FOR THE AMERICAN MERCHANT
MARINE MEMORIAL: PLAN, 1987
(removed by Wilmarth from sketchbook)
Black ink on white wove paper
27.9 x 22 cm
The Christopher Wilmarth Archive, gift of Susan
Wilmarth-Rabineau
CW2001.803.2

28
DESIGN FOR THE AMERICAN MERCHANT
MARINE MEMORIAL: THE VESSEL OF SOULS/
TEMPLE OF SOULS, 1987
(removed by Wilmarth from sketchbook)
Black ink on white wove paper
27.9 x 22 cm
The Christopher Wilmarth Archive, gift of Susan
Wilmarth-Rabineau
CW2001.803.6

29
STUDY OF SCULPTURE, c. 1987
Graphite on cream wove paper
11.9 x 17.6 cm
The Christopher Wilmarth Archive, gift of Susan
Wilmarth-Rabineau
CW2001.805.2 (fol. 2-recto)

30
STUDY OF SCULPTURE, 1987
Black ink on white wove paper
14 x 10.2 cm
The Christopher Wilmarth Archive, gift of Susan
Wilmarth-Rabineau
CW2001.801.8 (fol. 8-recto)

31
DRAWING, 1970
Etched glass with graphite
30.5 x 30.5 x 2.5 cm
Loan from the Collection of Forrest Myers
TL38320

32
TIED DRAWING, 1971
Etched glass and steel cable
43.2 x 43.2 x 2.5 cm
Loan from the Estabrook Foundation, Carlisle,
Mass.
TL38331.2

33
UNTIED DRAWING, 1971
Etched glass and steel cable
48.2 x 43.2 x 2.5 cm
Loan from the Collection of George G. Hadley
and Richard L. Solomon
TL38323

34
CROSSCUT DRAWING, 1972
Etched glass and steel cable
43.2 x 43.2 x 2.5 cm
Private collection, New York
TL38327

35
SHADY GIBSON, 1971
Etched glass and steel cable
64.8 x 43.2 x 10.1 cm
Courtesy of Nina Nielsen and John Baker,
Promised gift to the Fogg Art Museum
TL38331.1

36
STREAM, 1973
Graphite and staples on layered translucent
vellum paper
46 x 30.7 cm
The Melvin R. Seiden Fund
1973.103

37
BLACK CLEARING #4 FOR HANK WILLIAMS, 1973
Graphite on layered white wove paper
20.3 x 20 cm
Loan from the Collection of Sarah-Ann and
Werner H. Kramarsky
TL38321.1

38
INVITATION #1, 1976
Graphite, graphite wash, and staples on layered
translucent vellum paper
55.8 x 59.9 cm
Margaret Fisher Fund
2001.149

39
THREE DRAWINGS FOR "CALLING," 1974
Watercolor and graphite on layered cream wove
paper
Each 17.9 x 25.8 cm
Margaret Fisher Fund
2000.170–173

40
DRAWING FOR "CALLING," 1974
Graphite and staples on layered translucent
vellum paper, mounted to white wove paper
28 x 50.8 cm
Loan from the Collection of Sarah-Ann and
Werner H. Kramarsky
TL38321.2

41
CALLING, 1976
Pastel and graphite on folded and layered brown
wove paper
23.2 x 30.5 cm
Margaret Fisher Fund
2001.147

42
CALLING, 1976
Graphite, graphite wash, and staples on layered
translucent vellum paper
55.9 x 73.7 cm
Margaret Fisher Fund
2001.148

43
"WHEN WINTER ON FORGOTTEN WOODS MOVES
SOMBER ...," 1979
Pastel and graphite on layered cream modern laid
paper
66.3 x 48.9 cm

Private collection, New York
TL38328

44
SAINT, 1979
Charcoal on layered cream modern laid paper
67.0 x 49.2 cm
Margaret Fisher Fund
2001.146

45
"THE WHOLE SOUL SUMMED UP ...," 1979
Pastel and graphite on layered cream modern
laid paper
67.0 x 48.5 cm
Margaret Fisher Fund
1998.74

46
"WHEN WINTER ON FORGOTTEN WOODS MOVES
SOMBER ...," 1979
Watercolor and graphite on layered off-white
wove paper
25.9 x 18 cm
Courtesy of Nina Nielsen and John Baker,
Promised gift to Fogg Art Museum
TL38331.3

47
"MY OLD BOOKS CLOSED ...," 1979
Watercolor and graphite on layered off-white
wove paper
25.9 x 18 cm
Courtesy of Nina Nielsen and John Baker,
Promised gift to Fogg Art Museum
TL38331.4

48
"Insert myself within your story …," 1979
Watercolor and graphite on layered off-white
wove paper
25.9 x 18 cm
Courtesy of Nina Nielsen and John Baker,
Promised gift to Fogg Art Museum
TL38331.5

49
Sigh, 1979
Watercolor and graphite on layered off-white
wove paper
25.9 x 18 cm
Courtesy of Nina Nielsen and John Baker,
Promised gift to Fogg Art Museum
TL38331.6

50
Saint, 1979
Watercolor and graphite on layered off-white
wove paper
25.9 x 18 cm
Courtesy of Nina Nielsen and John Baker,
Promised gift to Fogg Art Museum
TL38331.7

51
Toast, 1979
Watercolor and graphite on layered off-white
wove paper
25.9 x 18 cm
Courtesy of Nina Nielsen and John Baker,
Promised gift to Fogg Art Museum
TL38331.8

52
"The whole soul summed up …," 1979
Watercolor and graphite on layered off-white
wove paper
25.9 x 18 cm
Courtesy of Nina Nielsen and John Baker,
Promised gift to Fogg Art Museum
TL38331.9

53
Twelve Drawings from the Forty-fourth
Year, #2: Emanation (for Enzo and Me), 1987
Graphite and ink wash on layered gesso- and
rabbitskin-glue-prepared off-white wove paper
20.4 x 16 cm
Loan from the Collection of Martin and
Deborah Hale
TL38269.2

54
Twelve Drawings from the Forty-fourth
Year, #9: Moment, 1987
Graphite and watercolor on layered gesso- and
rabbitskin-glue-prepared off-white wove paper
18 x 16 cm
Loan from the Collection of Martin and
Deborah Hale
TL38269.1

55
Twelve Drawings from the Forty-fourth
Year, #12: Delancey Backs, 1987
Graphite on gesso-prepared off-white wove paper
25.4 x 21.6 cm
Loan from the Collection of Sarah-Ann and
Werner H. Kramarsky
TL38321.3

56
Untitled, 1987
Graphite and graphite wash on gesso-prepared
off-white wove paper
53.4 x 42.9 cm
Margaret Fisher Fund
2000.174

57
Untitled, 1987
Graphite and graphite wash on gesso- and
rabbitskin-glue-prepared off-white wove paper
76.3 x 106.8 cm
Loan from Susan Wilmarth-Rabineau, Courtesy of
Robert Miller Gallery, New York
TL38333

58
Untitled, 1987
Graphite on gesso- and rabbitskin-glue-prepared
off-white wove paper
58.1 x 38.4 cm
Private collection, New York
TL38326

BIBLIOGRAPHY

The following represents a selection of books, exhibition catalogues, and periodical articles that discuss Christopher Wilmarth and his art. For a more comprehensive bibliography, the reader's attention is directed to the forthcoming monograph on Christopher Wilmarth from Princeton University Press.

Anderson, Alexandra. "Christopher Wilmarth: Portfolio." *The Paris Review* 15, no. 58 (summer 1974): 102–10.

Artner, Alan. "Abstract Reflection." *Chicago Tribune,* October 14, 2001.

Ashton, Dore. "Radiance and Reserve: The Sculpture of Christopher Wilmarth." *Arts Magazine* 45, no. 5 (March 1971): 31–33.

_____. *Drawings by New York Artists.* Exh. cat., Utah Museum of Fine Arts. Salt Lake City, 1972.

_____. "Christopher Wilmarth's Gnomic Sculpture." *Arts Magazine* 55, no. 4 (December 1980): 93–95.

_____. "Mallarmé, Friend of Artists." In *Christopher Wilmarth: Breath,* 9–23. Exh. cat., The Studio for the First Amendment. New York, 1982.

_____. "Christopher Wilmarth: Layers." In *Christopher Wilmarth: Layers, Works from 1961–1984,* 3–12. Exh. cat., Hirschl and Adler Modern. New York, 1984. (Republished as "Christopher Wilmarth: Layers." *Cimaise* 31, no. 169 [March/April 1984]: 69–72).

_____. "Homage to Christopher Wilmarth." *At Cooper Union* (spring 1990): 6–7.

Beardsley, John. *Spectrum: Three Sculptors: Chris Wilmarth, John Duff, Peter Charles.* Exh. cat., The Corcoran Gallery of Art. Washington, D.C., 1987.

Boyce, Roger. "Through a Glass Darkly: Christopher Wilmarth." *Art New England* 22, no. 4 (June/July 2001): 22–23.

Butterfield, Jan. "New Beauty." *Pacific Sun,* March 28–April 3 1974.

Calo, Carole Gold. "Nielsen Gallery/Boston: Christopher Wilmarth." *Art New England* 15, no. 1 (December 1993/January 1994): 54.

Camper, Fred. "Christopher Wilmarth: Light Heavyweight." *Chicago Reader* 31, no. 2 (October 12, 2001): 34–35.

Coppola, Regina. "Living Inside." In *Christopher Wilmarth,* 7–33. Exh. cat., Arts Club of Chicago. Chicago, 2001.

Corn, Alfred. "Reveries in Glass and Steel." *Art News* 88, no. 8 (October 1989): 201.

Dietz, Paula. "Constructing Inner Space." *New York Arts Journal* 9 (April/May 1978): 26–28.

Edelman, Robert G. "Christopher Wilmarth at Sidney Janis." *Art in America* 83, no. 6 (June 1995): 103.

Edinborough, Arnold. "'American Accents': A Tribute to the Passion to Communicate." *Financial Post,* June 25, 1983.

Galleria dell'Ariete. *Chris Wilmarth: Sculpture.* Exh. cat., Galleria dell'Ariete. Milan, 1973.

Gelburd, Gail, and Geri De Paoli. *The Thread: Asian Philosophy in Recent American Art.* Exh. cat., Hofstra Museum, Hofstra University, and Edith C. Blum Art Institute, Bard College. Hempstead, N.Y. and Annandale-on-Hudson, N.Y., 1990.

Geldzahler, Henry, and Christopher Scott. *Christopher Wilmarth: Sculpture and Drawings.* Exh. cat., Grey Art Gallery & Study Center, New York University. New York, 1977.

Gibson, Eric. "Christopher Wilmarth." *Sculpture* 7, no. 3 (May/June 1988): 35.

_____. "Wilmarth and Serra." *The New Criterion* 8, no. 2 (October 1989): 51–55.

Glueck, Grace. "Christopher Wilmarth: Graham Gallery." *Art in America* 56, no. 5 (September/October 1968): 112.

_____. Christopher Wilmarth: Paula Cooper Gallery." *Art in America* 59, no. 2 (March/April 1971): 46–47.

_____. "Mallarmé Poems Inspire Glass Sculpture." *New York Times,* May 14, 1982.

_____. "Christopher Wilmarth's 'Layers'." *New York Times,* March 23, 1984.

_____. "Christopher Wilmarth: Sidney Janis Gallery." *New York Times,* April 4, 1997.

Graham Gallery. *Christopher Wilmarth.* Exh. cat., Graham Gallery. New York, 1968.

Hagenberg, Roland. "The Sun Is Just a Square Upon the Wall." *Artfinder* (spring 1987): 60–65.

D'Harnoncourt, Anne. *8 Artists.* Exh. cat., Philadelphia Museum of Art. Philadelphia, 1978.

Henry, Gerrit. "Christopher Wilmarth at Hirschl and Adler Modern." *Art in America* 72, no. 8 (September 1984): 212–13.

Hirschl and Adler Modern. *Cy Twombly, Christopher Wilmarth, Joe Zucker.* Exh. cat., Hirschl and Adler Modern. New York, 1986.

_____. *Christopher Wilmarth: Drawings 1963–1987.* Exh. cat., Hirschl and Adler Modern. New York, 1989.

Horowitz, Stash. "Magic, Not Merchandise." *The Back Bay Courant,* April 28, 1998.

Hughes, Robert. "Poetry in Glass and Steel." *Time* (June 26, 1989): 88.

Kalina, Richard. "Christopher Wilmarth at Sidney Janis." *Art in America* 85, no. 10 (October 1997): 117–18.

Kimmelman, Michael. "Sculptures at the Modern by Christopher Wilmarth." *New York Times,* June 23, 1989.

_____. "Christopher Wilmarth: Sidney Janis Gallery." *New York Times,* March 17, 1995.

Kingsley, April. *Dialogue: Shapiro, Wilmarth.* Exh. cat., Huntington Galleries. Huntington, W. Va., 1978.

Kotik, Charlotte. *Working in Brooklyn/Sculpture.* Exh. cat., Brooklyn Museum of Art. New York, 1985.

Kramer, Hilton. "The Delicate Touch of a Constructivist." *New York Times,* December 8, 1974.

_____. "Christopher Wilmarth." *New York Times,* January 20, 1978.

_____. "A Sculptor in Pursuit of the Poetry in Light and Shadow." *New York Observer,* June 5, 1989.

Krane, Susan, Robert Evren, and Helen Raye. *Albright-Knox Gallery: The Painting and Sculpture Collection: Acquisitions since 1972.* New York, 1987.

Kunitz, Daniel. "Christopher Wilmarth: Every Other Shadow Had a Song to Sing." *New Criterion* 18, no. 10 (June 2000): 50–51.

Kuspit, Donald. "Christopher Wilmarth: Museum of Modern Art." *Artforum* 28, no. 2 (October 1989): 170.

_____. "Christopher Wilmarth: Sidney Janis Gallery." *Artforum* 33, no. 9 (May 1995): 98.

Larson, Philip. "Christopher Wilmarth at N.Y.U.'s Grey Gallery and the 'Studio for the First Amendment'." *Art in America* 66, no. 3 (May/June 1978): 117.

Linker, Kate. "Christopher Wilmarth: Nine Clearings for a Standing Man." *Arts Magazine* 49, no. 8 (April 1975): 52–53.

Littman, Brett. "Christopher Wilmarth's Glass Poems." *Glass: The UrbanGlass Art Quarterly,* no. 71 (summer 1998): 44–47.

Lubowsky, Susan. *Sculpture Since the Sixties: From the Permanent Collection of the Whitney Museum of American Art.* Exh. cat., Whitney Museum of American Art at Equitable Center. New York, 1988.

Lyon, Christopher. "Another Place for Dreams." *The Members Quarterly of The Museum of Modern Art* 2, no. 1 (summer 1989): 12 and 23.

Madoff, Steven Henry. "Christopher Wilmarth at the Studio for the First Amendment." *Art in America* 70, no. 10 (November 1982): 119–20.

Marlow, Peter O. *Christopher Wilmarth: Matrix 29.* Exh. cat., The Wadsworth Atheneum Museum of Art. Hartford, Conn., 1977.

Masheck, Joseph. "Chris Wilmarth." *Artforum* 10, no. 10 (June 1972): 81.

———. "Chris Wilmarth, Rosa Esman Gallery." *Artforum* 12, no. 9 (May 1974): 65–66.

———. "Wilmarth's New Reliefs." In *Christopher Wilmarth: Nine Clearings for a Standing Man.* Exh. cat., The Wadsworth Atheneum Museum of Art. Hartford, Conn., 1977.

McDonald, Robert. "Chris Wilmarth." *Artweek* (Oakland, Calif.) 5, no. 12 (March 23, 1974): 5.

———. "Rich Effects in Steel and Glass." *Artweek* (Oakland, Calif.) 9, no. 32 (September 30, 1978): 1.

McFadden, Robert D. "Christopher Wilmarth, Artist, Is Apparent Suicide." *New York Times,* November 20, 1987.

McQuaid, Cate. "Reflecting on Works Both Light and Dark; Christopher Wilmarth: Layers, Clearings, Breath." *Boston Globe,* April 30, 1998.

Megged, Matti. "The Void and the Dream: New Sculptures by Christopher Wilmarth." *Arts Magazine* 61, no. 10 (June/summer 1987): 74–75.

Naves, Mario. "Christopher Wilmarth." *New Criterion* 14, no. 6 (February 1996): 49–51.

———. "The Simplicity Rothko Longed For, in Wilmarth's Uncanny Sculpture." *New York Observer,* May 8, 2000.

Nielsen Gallery. *Christopher Wilmarth: Layers, Clearings, Breath.* Exh. cat., Nielsen Gallery. Boston, 1998.

Noble, Alastair. "Christopher Wilmarth: Robert Miller Gallery." *Sculpture* 19, no. 9 (November 2000): 59–60.

Pincus-Witten, Robert. "Christopher Wilmarth, A Note on Pictorial Sculpture." *Artforum* 9, no. 9 (May 1971): 54–56.

Poirier, Maurice. "Christopher Wilmarth: The Medium Is Light." *Art News* 84, no. 10 (December 1985): 68–75.

Robins, Corinne. "The Circle in Orbit." *Art in America* 56, no. 6 (November/December 1968): 62–63.

Rosenstock, Laura. "Christopher Wilmarth: An Introduction." In *Christopher Wilmarth,* 10–18. Exh. cat., Museum of Modern Art. New York, 1989.

Rosenthal, Mark. *Christopher Wilmarth: Sculpture and Drawings from the 1960s and 1980s.* Exh. cat., Sidney Janis Gallery. New York, 1997.

Rubinfien, Leo. "Christopher Wilmarth, Grey Art Gallery, N.Y.U., and Studio for the First Amendment." *Artforum* 16, no. 7 (March 1978): 70–72.

Schultz, Douglas G. *Eight Sculptors.* Exh. cat., Albright-Knox Art Gallery. Buffalo, N.Y., 1979.

Schwabsky, Barry. "Chris Wilmarth." *Arts Magazine* 61, no. 5 (January 1987): 121.

Schwendenwien, Jude. "Christopher Wilmarth: Hirschl and Adler Modern." *Sculpture* 15, no. 6 (July/August 1996): 59–60.

Seattle Art Museum. *Christopher Wilmarth.* Exh. cat., Seattle Art Museum. Seattle, 1979.

Sidney Janis Gallery. *Christopher Wilmarth.* Exh. cat., Sidney Janis Gallery. New York, 1995.

Stoops, Susan. *The Contemporary Drawing: Existence, Passage and the Dream.* Exh. cat., Rose Art Museum, Brandeis University. Waltham, Mass., 1991.

Taylor, Robert. "Christopher Wilmarth: Breath." *Boston Globe,* April 10, 1983.

Unger, Miles. "Christopher Wilmarth: Layers, Clearings, Breath at Nielsen Gallery." *Sculpture* 17, no. 9 (November 1998): 70–71.

Wasserman, Emily. "Christopher Wilmarth, Graham Gallery." *Artforum* 7, no. 5 (January 1969): 59–60.

Wilmarth, Christopher. [Statement]. In Corinne Robins, "The Circle in Orbit." *Art in America* 56, no. 6 (November/December 1968): 63.

———. [Statement]. In *Christopher Wilmarth: Nine Clearings for a Standing Man.* Exh. cat., The Wadsworth Atheneum Museum of Art. Hartford, Conn., 1974.

———. "The True Story of the Gift of the Bridge." In Peter O. Marlow, *Christopher Wilmarth: Matrix 29.* Exh. cat., The Wadsworth Atheneum Museum of Art. Hartford, Conn., 1977.

_____. *Breath: Inspired by Seven Poems by Stéphane Mallarmé Translated by Frederick Morgan.* New York, 1982. (Reprinted as "Pages, Places and Dreams [or The Search for Jackson Island]." *Poetry East,* nos. 13 and 14 [spring/summer 1984]: 174–76.)

_____. "Seven Interviews by Celadón." In *Chris Wilmarth: Delancey Backs (and Other Moments),* 6–33. Exh. cat., Hirschl and Adler Modern. New York, 1986.

_____. *Remembrance: A Memorial to those American Merchant Marines who lost their lives in peaceful commerce and in wars against foreign foes, in defense of the freedom this nation now enjoys.* Privately published in a limited edition of 20 copies, 1987.

Worth, Alexi. "Christopher Wilmarth: Sidney Janis." *Art News* 96, no. 3 (March 1997): 109.

Yood, James. "Christopher Wilmarth." *Artforum* 40, no. 6 (February, 2002): 134–35.

Zucker, Barbara. "Christopher Wilmarth." *Art News* 77, no. 9 (November 1978): 181.

Photo credits